POSTCARD HISTORY SERIES

Roton Point

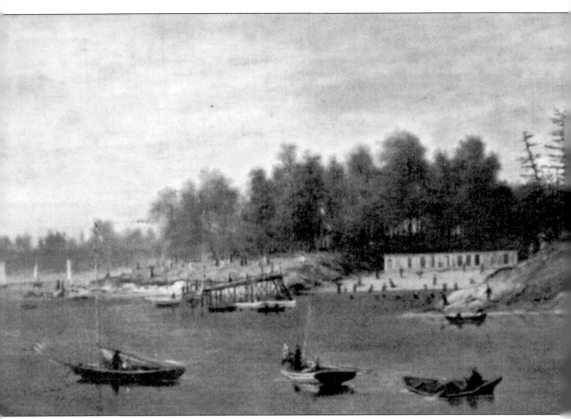

This 1878 oil painting by Jos. Inman shows Roton Point's grove, bathhouses, and the beach. (Photograph by Lisa Wilson Grant; courtesy of the Bain family.)

ON THE FRONT COVER: Beachgoers enjoy a beautiful, sunny day at Roton Point Park. As a family-friendly park, families could play on the beach and in the water and later picnic in the grove. (Courtesy of Lisa Wilson Grant.)

ON THE BACK COVER: Roton Point's Ferris wheel was named Ocean Wave and can be seen on the left side in this view of the midway. A fire consumed the west end of the carriage sheds (in the background) along with the Ocean Wave in 1913. (Courtesy of the Robinson family.)

POSTCARD HISTORY SERIES

Roton Point

Roton Point History Committee

ARCADIA
PUBLISHING

Published by Arcadia Publishing
Charleston, South Carolina

Printed in the United States of America

Library of Congress Control Number: 2010935394

For all general information contact Arcadia Publishing at:
Telephone 843-853-2070
Fax 843-853-0044
E-mail sales@arcadiapublishing.com
For customer service and orders:
Toll-Free 1-888-313-2665

Visit us on the Internet at www.arcadiapublishing.com

CONTENTS

ACKNOWLEDGMENTS

The earliest photographs in my baby book were taken in 1963 at Bayley Beach, which was once part of Roton Point Park. Although I did not know it in its amusement park days, growing up in Rowayton, the clues were all around—buildings that changed very little and cement footings of the arch entranceway and carousel pad were (and still are) apparent years later. I started collecting postcards of that bygone era, studying the details with a magnifying glass for even more clues. My postcard collection pales in comparison to that of the Robinson family, and much of the information learned came from images and notes put together by Louise Robinson. I am also appreciative of the Simmons collection and for the work of previous Roton Point History Committees that gathered and scanned images for our archives. I am thankful for Mary Cohn for all her organizational work at the Rowayton Historical Society (RHS), as well as for Wendell Livingston and Lesley Korzennik. Frank Raymond's book *Rowayton on the Half Shell* and RHS's *Historic Rowayton* were invaluable resources. Thanks to Dana Laird for train information, and Pat Rowan for identifying her husband's family members in one of the postcards. Caption writing and production work was done by Pat Atkin, myself, and especially Mary Ellen Pastore with the introduction and chapter start pages written by Cam Hutchins, who also did a great job weaving everything together. I am most appreciative for all of their work in order to bring this book to fruition and their patience in working with my hectic schedule. Thanks to Charlie Janson, Caroline Robinson, and other board members who enabled us to proceed with this project and for club manager Ernie LaRocca for allowing us to impose upon his office for our production work. I am also thankful for the pictorial contributions of Stan Pastore, Betsy Bain, and the Palladino family. I am appreciative of the Roton Point memories shared by Judy Nan Hacohen, Grace Sartor, Charlie Pfahl, Paul Lee, Myrtle Eleck, and Rose Valentik, as well as the many others that shared tidbits of information too numerous to mention. I am thankful for my husband, Jordan Grant, and his patience and for my dad, Don Wilson, who manages the Sixth Taxing District's Bayley Beach, for allowing the Roton Point History Committee to share our common history there.

—Lisa Wilson Grant
Committee Chair, Roton Point History Committee
Roton Point Association, Rowayton, Connecticut

INTRODUCTION

From at least the mid-19th century on, Roton Point, in the Rowayton section of Norwalk, Connecticut, has been many things to many people. While the area had apparently been used during the American Revolution as a salt pan (salt being a crucial meat preservative), the earliest traces of what was to become Roton Point Park showed up as the 19th century neared its end. An 1867 map of Norwalk depicts today's Roton Point, Bayley Beach, and Wee Burn Beach as a tidal area, actually separate from the mainland at high tide. No doubt this inaccessibility helped keep the spot from being developed for housing or other more typical uses.

Owned by Charles L. Raymond, Roton Point was used mostly by locals for swimming and picnicking. With its sandy beaches between rock outcroppings and high, shady grove overlooking Long Island Sound, the location is one that must have been irresistible for those looking for a cool and relaxing respite from a hot summer's day. It still is.

Such a location was bound to be discovered. An 1872 map of the area shows three buildings on-site, but with rapid improvements in public transportation, Roton Point was growing in both accessibility and popularity. By 1875, the property had been transferred to Jacob B. Raymond and excursion steamers such as the *Rosedale* were beginning to make the run from New York City up to Roton Point, bringing literal boatloads of New Yorkers in need of a getaway. Throughout the 1880s, the Raymond family leased the property out to August R. Ackert, who managed the operations; more facilities were added to the park—including a two-lane bowling alley in the hotel—as Roton Point evolved into a full-fledged amusement park. Admission was 10¢ through the western park entrance, and midway games included "Ring the Canes" and "Kill the Kaiser;" concessions such as Pfahl's glassblowing booth did brisk business as well.

In 1891, Roton Point Park was sold to investors Catherine and Julius Finkelstein and James E. Kelley, who formed a New Jersey corporation, the Roton Point Improvement Company. A map from 1892 shows a number of buildings within the park, including horse sheds, the hotel, the dance pavilion, the bathhouse, the carousel, the tintype gallery, and, notably, the 100-foot pier jutting out into the sound from the tip of Pine Point. Adding to the momentum, May 25, 1894, was considered an exciting day by many Norwalk residents as the first electric trolley car went into Roton Point.

Not coincidentally, control of Roton Point was soon assumed by the Connecticut Company, a trolley operator that saw Roton Point as an attractive destination. Sure enough, trolley cars departed from South Norwalk to Roton Point every 20 minutes, and passengers gladly paid 5¢ a ride.

The arrival at Roton Point of Neville Bayley, a British-born immigrant with experience in the construction and operation of amusement park rides (especially roller coasters), proved especially

fortuitous. Having already worked with Savin Rock Park in New Haven, Connecticut, Bayley saw an opportunity and, in 1914, acquired a 20-year lease of the park from the Connecticut Company. His vision and energy made sure that Roton Point was developed as a family-focused park and would earn its claim as "the prettiest park on Connecticut's shore." Neville Bayley purchased Roton Point from the Connecticut Company's successor (the Connecticut Railway and Lighting Company) in 1928.

Under Bayley's hand, Roton Point Park reached a pinnacle of success that is still remarkable. In addition to building a new, more daring roller coaster, Roton Point even built its own excursion steamer, the *Belle Island*, and operated it between New York and Roton Point, along with all the other boats coming in. On one day in the 1920s, nine of the boats arrived, each carrying close to 2,000 passengers. Sunday nights were booked with big bands that performed in the dance pavilion, drawing thousands of fans.

This book may remind readers that all good things must end, or at least change. Buffeted by the 1938 hurricane and wartime austerity, Roton Point Park closed for good after the 1941 season, and the original property is today split into three entities—the Roton Point Association, Bayley Beach (for the Sixth Taxing District of Norwalk), and the Wee Burn Beach Club. Several of the old buildings (hotel, bathhouse, gazebo, roller coaster entry) are still standing, renovated for new uses, and proudly wear historical plaques from the Rowayton Historical Society.

But this book is focused on the days of Roton Point Park and is largely illustrated by postcards of Roton Point and the immediate vicinity. To collectors, postcards belong in the realm of ephemera, fleeting printed artifacts that have still, somehow, survived. Luckily, the rise of Roton Point as an amusement park coincided with the golden age of postcard production, distribution, and popular usage, and the years of Roton Point Park are highly documented through the cards that were sold within the park itself. Through these cards, today's readers can catch glimpses of the lives people led years ago and the times they enjoyed at Roton Point. In fact, when reading handwritten messages on the postcards with phrases like, "Is this not a beautiful place?" (1905), "I went on the roller coaster six times, how would you like that?" (1915), and "This is a swell place, nice and cool." (1940), readers may realize how very similar they are to those who enjoyed Roton Point Park so many years ago.

One

GETTING TO THE PARK

"The annual Sunday-school excursion will be to Roton Point," the Reverend Henry Ward Beecher announced at his prayer meeting Friday night. "I've no idea where that desirable locality is, but I intend to find out." So began a *New York Times* article dated June 22, 1884, describing a church school trip to Roton Point Park. It must have been an agreeable outing, since the *Times* covered a similar trip a year later on June 28, 1885, when Reverend Beecher took an even larger group from his Plymouth Church in Brooklyn Heights, New York, up to Roton, this time aboard the excursion steamer *Grand Republic*.

Such trips were not unusual. Like many amusement parks at the start of the 20th century, Roton Point became a destination well before the advent of widespread personal transportation. With more leisure time on their hands, many Americans sought diversions and found they could rely on many modes of public transportation to get them there. For Roton Point, there were the steamships coming in from New York City, trolleys coming in from Norwalk, and eventually, buses and cars coming in from all over. Roton Point Park welcomed all of them.

In fact, from building the 100-foot pier at the end of Pine Point, to having its own trolley station, to opening its fields to buses and automobiles, Roton Point Park could be very accommodating indeed. Roton Point went so far as building its own steamer, the *Belle Island*, at a cost of $400,000 in 1924 and advertised its schedules throughout New York City.

For park visitors coming to Roton Point at the end of the 1800s and the start of the 1900s, it seems clear now that traveling to get to the beach was not a necessary evil, but part of the fun, whether it was the thrill of riding in an open-air trolley or the carefree joy of dancing on the decks of a steamship, as the *New York Times* reported the children of the Plymouth Church did as they made their way up Long Island Sound to arrive at Roton Point.

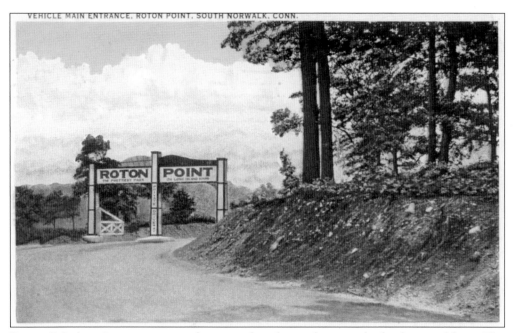

Roton Point's main entrance was the water, but those who came by land entered here. The cement foundations that once held the Roton Point entrance signposts are still evident today. (Courtesy of the Robinson family.)

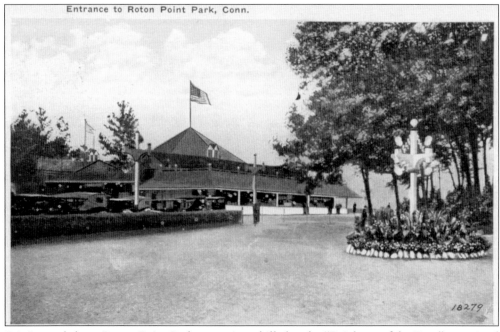

Entrance to Roton Point Park, Conn.

Pristine and clean, Roton Point Park, sometimes billed as the "Brighton of the East," contained numerous flower beds and picturesque gardens throughout. The automobiles would fill the lot to capacity on the weekends. (Courtesy of the Robinson family.)

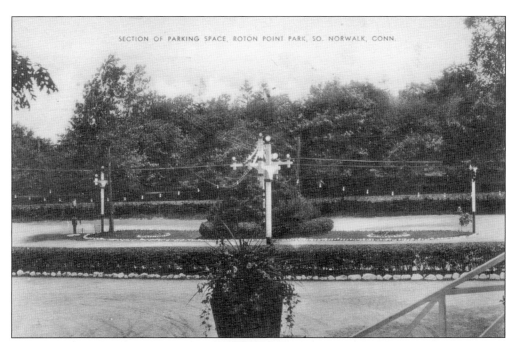

A large parking area was available for those willing to pay the high price of 25¢. Others left their cars on the local streets and walked in to save a quarter. (Courtesy of Roton Point Archives.)

This view from the hotel stairs focuses on the Victorian lampposts and strings of light bulbs, which are reminiscent of English seaside resorts. The trolley waiting station, not pictured here, is off to the left, and the bathhouse is on the right. (Courtesy of Lisa Wilson Grant.)

At the height of the season, an empty lot like this was a rare sight. In earlier days, this area was used for baseball games, but as automobile ownership became more popular, the land was converted to parking. (Courtesy of Lisa Wilson Grant.)

Near the end of the 19th century, it was not unusual to see a family in a horse-drawn carriage heading down a dirt road in Rowayton to enjoy a picnic in the grove. There were horse sheds in the parking area. In 1957, Judge Stanley Mead of New Canaan recalled details about church picnics he attended long ago in July after the haying season. The children came by horse-drawn wagon for a day filled with fishing, feasting, and swimming. Bathing suits could be rented if one forgot his own. The girls' suits even had stockings. The navy blue suits were all clearly stamped with Roton Point's "R.P." on the front. (Courtesy of the Robinson family.)

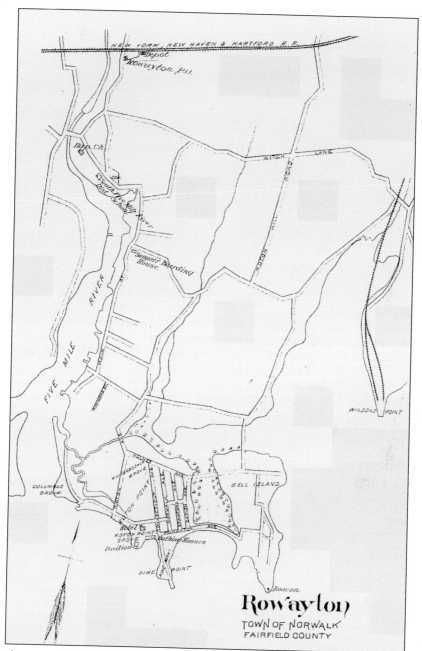

Seen here is a map of Rowayton around 1893, prior to the arrival of the trolleys. Most buildings on this map are not only in different locations today, but have been relocated two or three times. The Rowayton Post Office was in this location from 1868 to 1890, the Baptist Church from 1858 until 1905, and the South Five Mile River School 1848 to 1894; most streets now have different names. The two separate cities of South Norwalk and Norwalk finally merged together as one in 1913. Transportation by railroad was with the New York, New Haven, and Hartford Railroad. Also shown is Wilson's Point freight line, built in 1882 by Danbury and Norwalk Railroad, which later became the Housatonic Railroad (now abandoned). (Courtesy of Lisa Wilson Grant.)

The New York, New Haven, and Hartford Railroad was a major line from New York City to New Haven, Connecticut. In 1868, a train stop was added at the Five Mile River Depot, briefly named Grantville before becoming Rowayton. Rowayton is a section of Norwalk, Connecticut, that still maintains its small-town charm within the city of Norwalk. The falls at Chasmar's Pond dam are visible in the background. (Courtesy of Lisa Wilson Grant.)

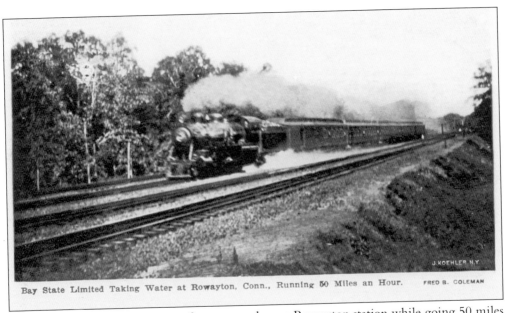

Bay State Limited Taking Water at Rowayton, Conn., Running 50 Miles an Hour. FRED B. COLEMAN

A steam engine is scooping water from a trough near Rowayton station while going 50 miles per hour. (Courtesy of Lisa Wilson Grant.)

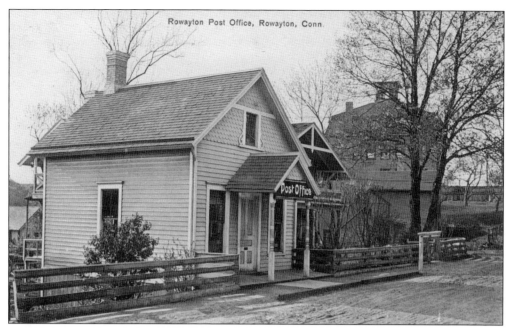

During the summer, the Rowayton Post Office, here in its 1890 location near the Rowayton train station, would hand cancel hundreds of postcards sent by Roton Point visitors each week. The Boylston Carriage Works, seen in the background, was the only manufacturer in Rowayton during the second half of the 19th century. (Courtesy of the Robinson family.)

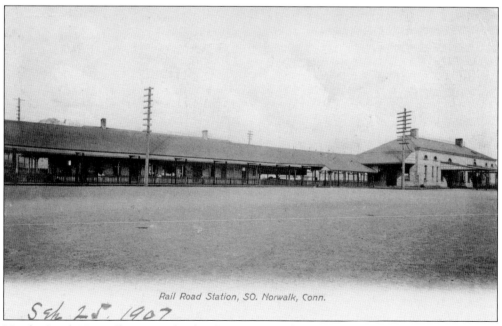

Nearby South Norwalk was another local train station that visitors headed towards Roton Point often used. (Courtesy of Lisa Wilson Grant.)

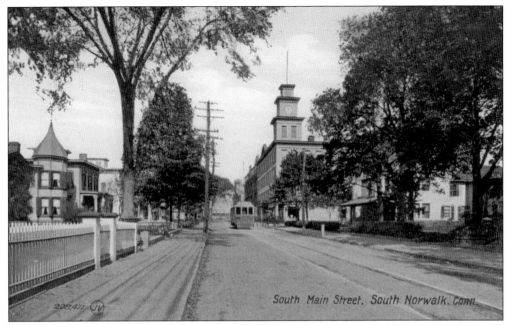

The trolley from South Norwalk cost 5¢. During peak season, there was a trolley car heading from or to South Norwalk every 20 minutes. (Courtesy of Lisa Wilson Grant.)

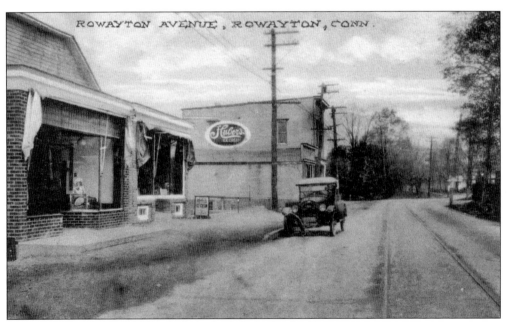

The trolley spur to Roton Point was opened in 1894. Passengers from Darien and Stamford heading east towards Roton Point would travel through the center of town on Rowayton Avenue. (Courtesy of the Robinson family.)

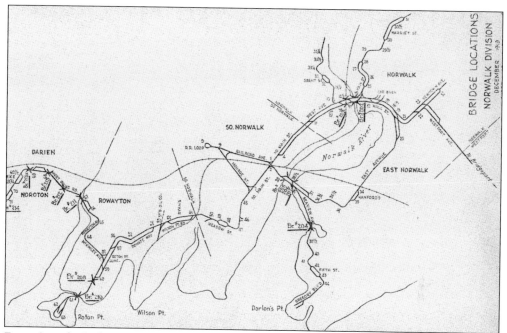

From Stamford, the trolley would go through Darien and cross the Five Mile River at the White Bridge on its own short trestle right next to the highway bridge. It would then enter the center of Cudlipp Street on an "S" curve and run right into the Rowayton turnout in Norwalk. It would then move out onto Rowayton Avenue on a single track in the center of the road, passing by homes and a church. It rounded "Bee Hive Curve" heading south into Rowayton past stores and homes, with the Five Mile River harbor on the right. It would take a left onto McKinley Street to Roton Junction, turn right onto a double track, and then into a side-of-the-road, right-of-way single-track line crossing Sammis Street at grade, and across the Farm Creek wooden trestle bridge. (Courtesy of Connecticut Motor Coach Museum Archives.)

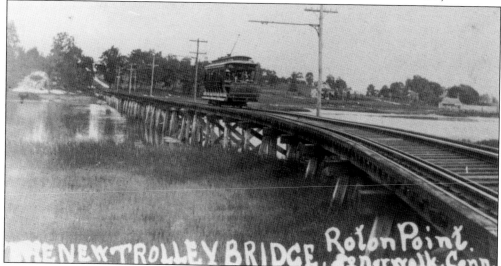

An open-air trolley travels across Farm Creek at Sammis Street. The wooden trestle bridge and tracks are long gone, but one can still see evidence of the old wooden pilings at this spot in Farm Creek. (Courtesy of the Simmons family.)

CANNON SQUARE, ROWAYTON, CONN.

Traveling east on the trolley, just before entering the town of Rowayton, there is a cannon that still exists today. The cannonballs, however, have long since disappeared. The gun was once on an old warship, the USS *Tallapoosa*, which served her country well during the Civil War. The cannon monument was dedicated to the veterans around 1901. The building in this photograph was a summer boardinghouse. Once known as the Montgomery House, and also as the Winthrop House, it was Ackert's Hotel in 1883. August Ackert, proprietor of Roton Point in 1880, lived here while he ran the restaurant, amusements, and hotel at Roton Point. Other concessionaires at Roton Point included the Jacobs Brothers, who leased Roton Point in 1909. Mike and Joe Jacobs later became famous boxing promoters, as well as editors and publishers of the *Ring* magazine, first published in 1922. (Courtesy of the Robinson family.)

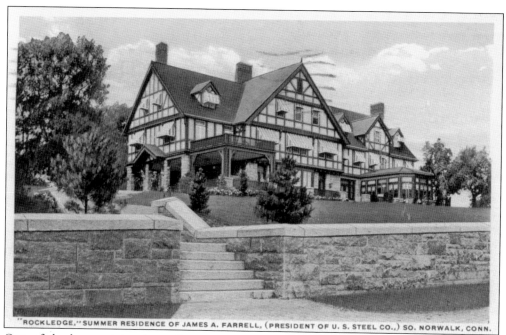

"ROCKLEDGE," SUMMER RESIDENCE OF JAMES A. FARRELL, (PRESIDENT OF U. S. STEEL CO.,) SO. NORWALK, CONN.

One of the large estates the trolley passengers would pass by was the summer residence of James A. Farrell, president of US Steel and founder of Farrell Steamship Lines. This house, constructed of wood, burned down during the wedding reception of Farrell's daughter in 1913 and was subsequently rebuilt in granite. (Courtesy of Lisa Wilson Grant.)

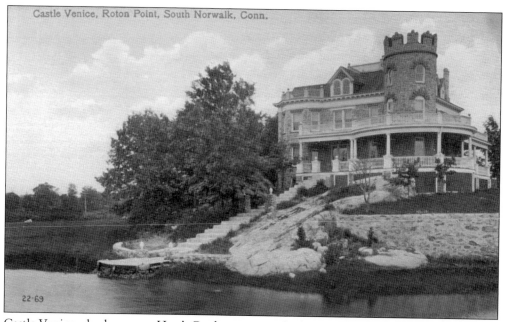

Castle Venice, Roton Point, South Norwalk, Conn.

22-69

Castle Venice, also known as Hart's Castle, was severely damaged in a fire in 1980 when a spark from the library fireplace ignited the old frame. (Courtesy of Lisa Wilson Grant.)

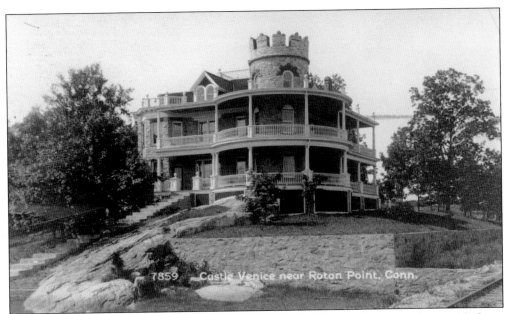

Although the original Castle Venice is no longer standing, its matching stone barn with fancy stone turrets still exists, and the property is now the Farm Creek Nature Preserve. (Courtesy of Lisa Wilson Grant.)

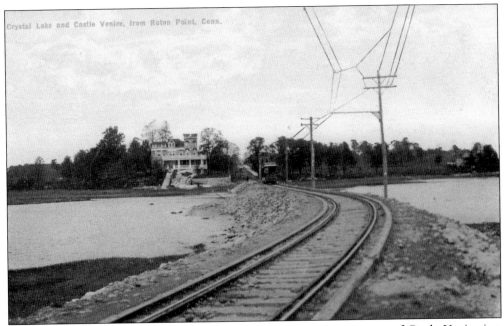

The trolley tracks towards Roton Point traveled alongside the property of Castle Venice just before heading over the trestle bridge. Unused for years, this trolley trestle burned down in 1954. (Courtesy of Lisa Wilson Grant.)

A trolley car is on Covewood Drive in Rowayton on November 3, 1933, just a week before abandonment of the line. Although the trolley tracks are long gone, this residential street still has the grassy median in its center. (Courtesy of the Rowayton Historical Society.)

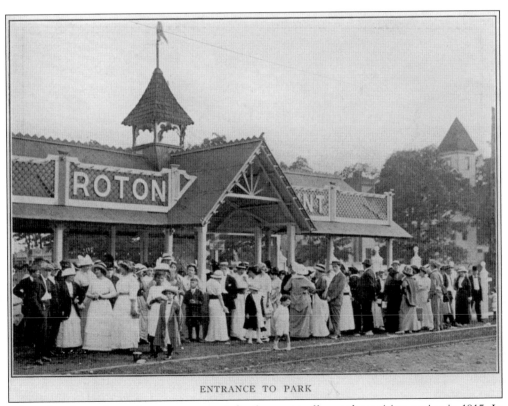

ENTRANCE TO PARK

After a fun day at the park, passengers wait for the next trolley at the waiting station in 1915. In 1916, the Connecticut Company operated trolleys at 20-minute intervals in and out of Roton Point. The fare was a nickel. (Courtesy of the Robinson family.)

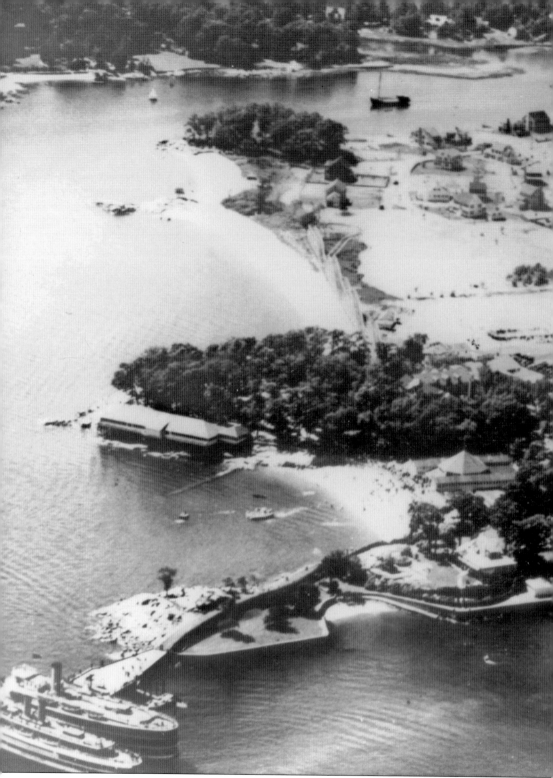

This aerial view of Roton Point shows the steamboat pier, the dance pavilion at the water's edge, the bathhouse with the octagonal roof, and the roller coaster along the beach. Beneath

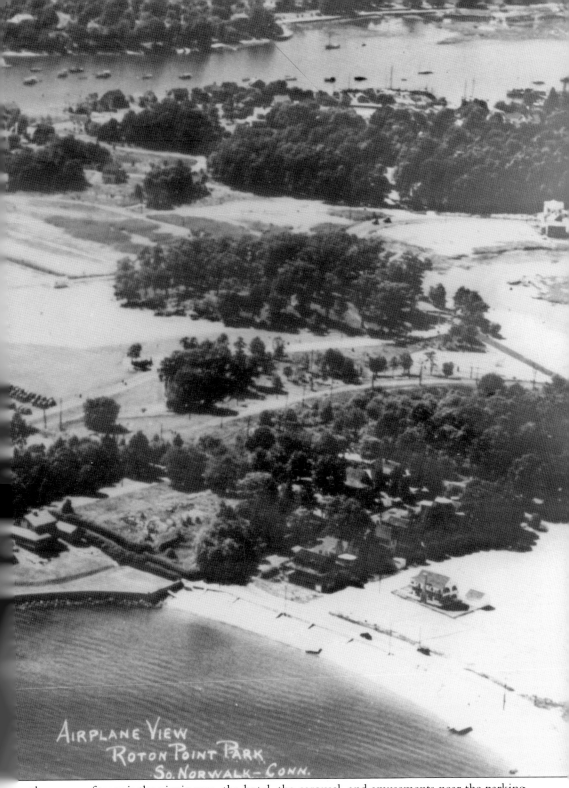

the grove of trees is the picnic area, the hotel, the carousel, and amusements near the parking lot. (Courtesy of the Robinson family.)

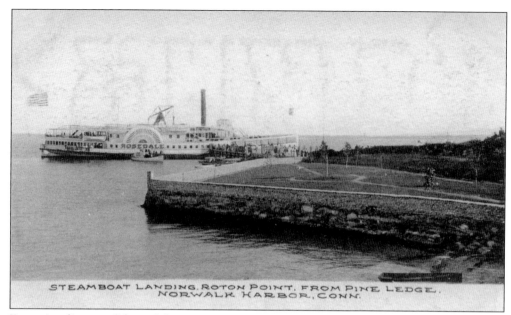

STEAMBOAT LANDING, ROTON POINT, FROM PINE LEDGE,
NORWALK HARBOR, CONN.

Excursion lines proliferated from New York City during the 1800s. Where there was an amusement park, there was an excursion line serving it. The *Rosedale* was one of the earliest to run to Roton Point Park around 1880. This is the view from Pine Park. (Courtesy of Lisa Wilson Grant.)

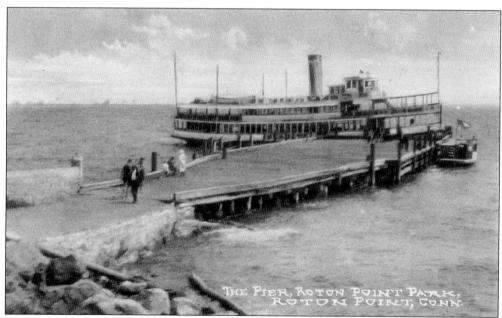

THE PIER, ROTON POINT PARK,
ROTON POINT, CONN.

Once disembarked from the three-hour journey to Roton Point, steamboat passengers were met at the large wooden pier. These boats would bring over 1,000 to 2,000 people each. They would often raft together at the dock, sometimes four vessels deep. (Courtesy of the Simmons family.)

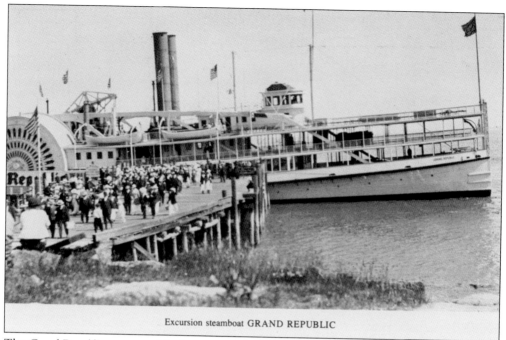

Excursion steamboat GRAND REPUBLIC

The *Grand Republic* was one of the largest to come to Roton Point. Built in 1878, she was 282 feet long with a 13-foot draft. Over time, she sustained a few mishaps, including a fire while leaving the Rockaways, and in 1911, she struck a sunken anchor off Coney Island that tore a hole in her bottom, causing a stampede of passengers to run ashore. (Courtesy of Lisa Wilson Grant.)

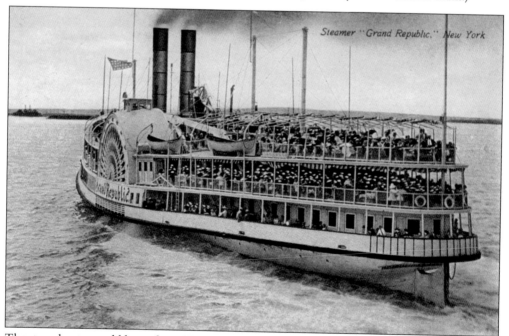

The steamboats would leave from New York and New Jersey for a day's outing. The trip would pull away from the dock at 9:00 a.m., arrive around noon, and depart from Roton Point at 5:30 p.m. The fare was $1.25. (Courtesy of the Simmons family.)

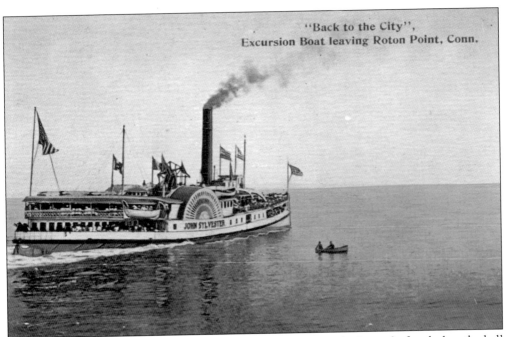

The *John Sylvester* was built in 1866 at Jersey City, New Jersey. At the end of each day, the bell at the Roton Point pier tolled when a steamer was sighted and would ring again 15 minutes before departure, reminding passengers that it was time to embark and head home. (Courtesy of the Robinson family.)

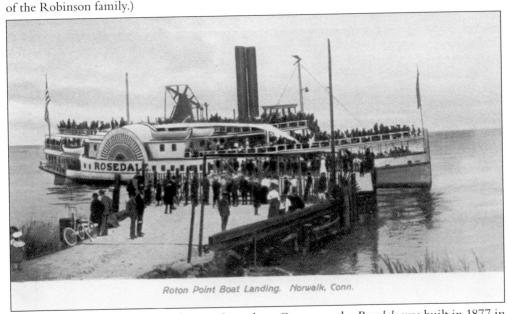

Roton Point Boat Landing. Norwalk, Conn.

Owned and operated by the Bridgeport Steamboat Company, the *Rosedale* was built in 1877 in Norfolk, Virginia. In 1896, she sunk in the East River in New York after striking the *Oregon* on a trip to Bridgeport, Connecticut; there was panic but no fatalities, and each blamed the other for what happened. Apparently, it was just a minor setback; refloated, she ultimately was chartered in 1918 for US Navy service, retaining her mercantile name. (Courtesy of Lisa Wilson Grant.)

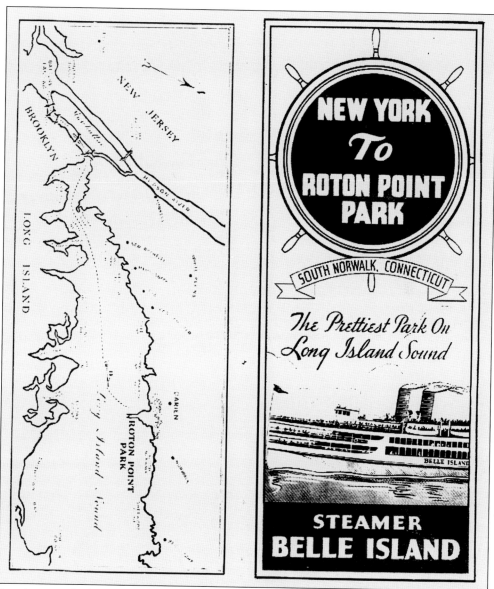

Seen here are the front and back of a brochure advertising the steamer *Belle Island*, including a map of her Long Island Sound route to Roton Point Park. (Courtesy of Roton Point Archives.)

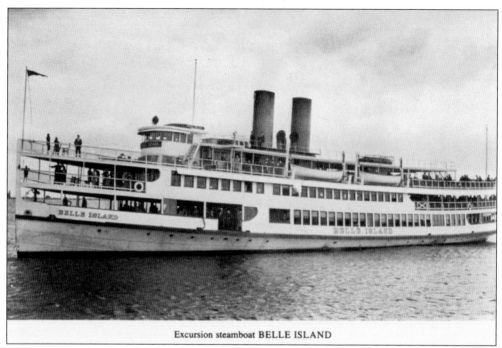

Excursion steamboat BELLE ISLAND

In 1924, Neville Bayley and a group of Norwalk businessmen had formed the Steamer Belle Island Co., Inc., and commissioned the *Belle Island*. She was an 842-gross-ton passenger ship, 212 feet long and with a 42-foot beam, completed in 1925 by Harry A. Marvel, Newburgh, New York. (Courtesy of Lisa Wilson Grant.)

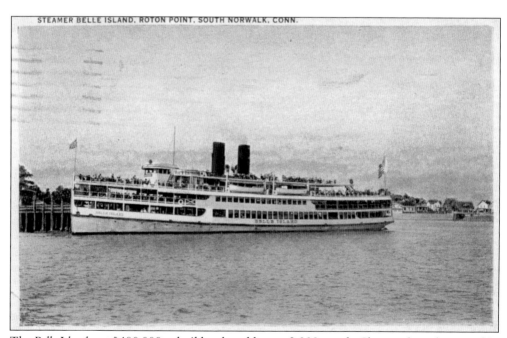

STEAMER BELLE ISLAND, ROTON POINT, SOUTH NORWALK, CONN.

The *Belle Island* cost $400,000 to build and could carry 2,000 people. She was the only steamship built for and owned by Roton Point. (Courtesy of Lisa Wilson Grant.)

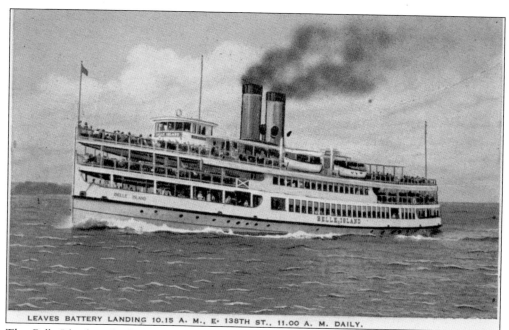

LEAVES BATTERY LANDING 10.15 A. M., E. 138TH ST., 11.00 A. M. DAILY.

The *Belle Island* made daily trips each morning from Battery Landing and East 138th Street, New York, to Roton Point and back at the end of the day. (Courtesy of the Simmons family.)

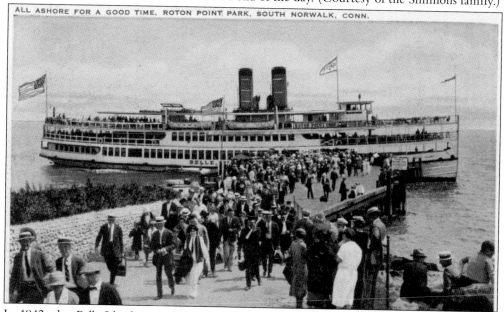

ALL ASHORE FOR A GOOD TIME, ROTON POINT PARK, SOUTH NORWALK, CONN.

In 1942, the *Belle Island* was sold to the US Army Transportation Corps and renamed *Col. James A. Moss*. In July 1942, she was lend-leased to the British Ministry of War Transport and managed by Coast Lines Ltd., London. In February 1943, she returned to America and was managed by Rubber Development Corporation (US government owned), spending her days ferrying rubber and supplies on the Amazon River. On June 10, 1943, she was sold following a boiler room fire at Santos and renamed *Maria De Lourdes* for Ary Cesar Burlamaque, Sao Paulo, Brazil. In 1955, she was reported as scrapped and deleted from Lloyds Register. (Courtesy of the Robinson family.)

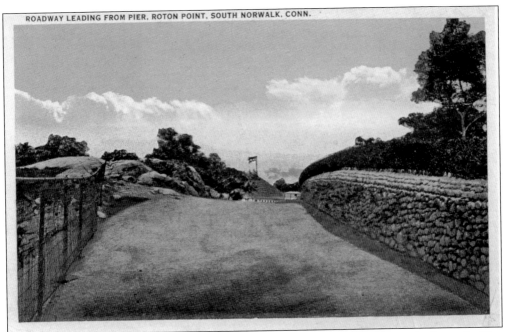

As passengers came off the pier, they would head down the roadway towards the park. The walls along the roadway are constructed of and capped with small, round stones, distinct to this shorefront area, particularly in the adjacent Pine Point and Bell Island sections of Rowayton. (Courtesy of Lisa Wilson Grant.)

Belle Island on Long Island Sound from Roton Point, Conn.

P.S. Was it pleasant or stormy last night

Charles E. Stevens was the mason known for his originality in the construction of these charming stone walls throughout the area. The stones were brought over from nearby Sheffield Island by rowboat. (Courtesy of Lisa Wilson Grant.)

Two

IN THE GROVE

One of the most outstanding and unusual features of Roton Point Park was the grove—the large, high park of trees, surrounded by water on two sides, jutting out into Long Island Sound. Its main use has not changed much in over 100 years; it remains a cool, shady place to enjoy a beach picnic with a tremendous view.

On the crest of the grove, overlooking Long Island Sound and originally built in the last part of the 19th century, the hotel at Roton Point is a landmark from the water. Over the years, postcard views show a building that was constantly evolving with additions on nearly all sides, including a large covered porch facing the water. There was a kitchen, an indoor restaurant, a two-lane bowling alley, private dining rooms, and a good number of hotel rooms up on the second floor.

The hotel featured an unusual construction method: the second floor and its hotel rooms were supported entirely by rods suspended from the roof rafters above. Throughout the hotel, details were typical of the era, including high ceilings, beadboard wainscoting, a long staircase, four-pane windows, porch latticework, and colored-glass square borders surrounding the door windows.

Although the hotel managed to survive the 1938 hurricane, the large rear ell section with its tower was taken down in the 1940s, leaving just the main hotel and large covered porch. By the end of the 20th century, after the park had become a beach club, the building was used primarily for hosting dances on the big porch with the upstairs rooms being used for storage. Faded sections of stenciled wall decoration could still be seen in some of the former hotel rooms, and each room still had a numbered paneled door along a long east-west central hallway; the feeling of a long-lost summer beach hotel was still palpable.

Patched, painted, and repaired sporadically through the years, the hotel (still called the hotel, though used more as a clubhouse) was stripped down to its studs in 2001 and rebuilt, keeping nearly all of the details that make it so recognizable from both land and from the sound.

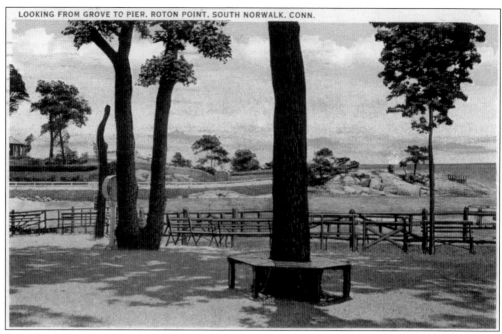

Seen from the picnic grove are Sunset Rock and to the right of it, the steamship pier. Visitors would disembark the steamships at the pier and walk along the road that is visible beyond the beach. (Courtesy of the Simmons family.)

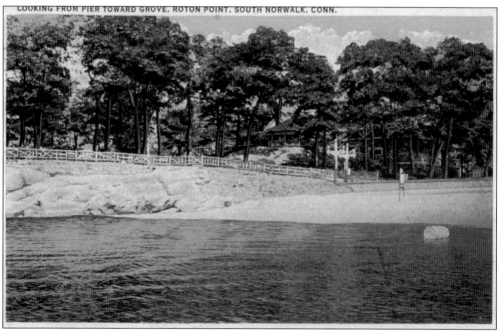

The gazebo and part of the hotel can be seen nestled amongst the shade trees of the grove, as viewed from the pier, with the beach in the foreground. (Courtesy of the Simmons family.)

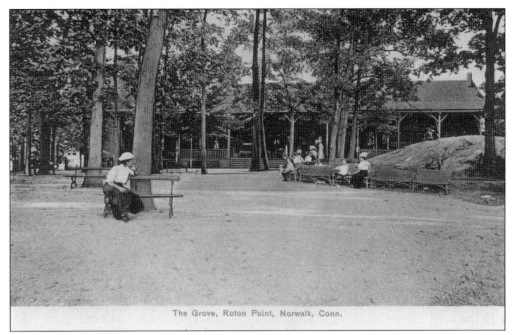

The Grove, Roton Point, Norwalk, Conn.

A turn-of-the-century view of the grove features the hotel in the background. This image can be dated by the women's clothing, as well as the rock outcropping, vacant of the gazebo, a feature added later in the 1920s. (Courtesy of Lisa Wilson Grant.)

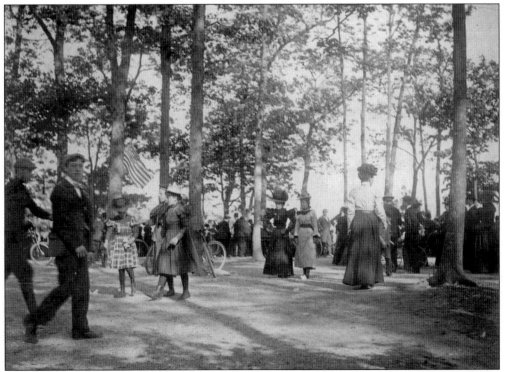

Sometime around 1898, visitors enjoy the shade of the grove, while wearing elegant clothing and hats. (Courtesy of the Robinson family.)

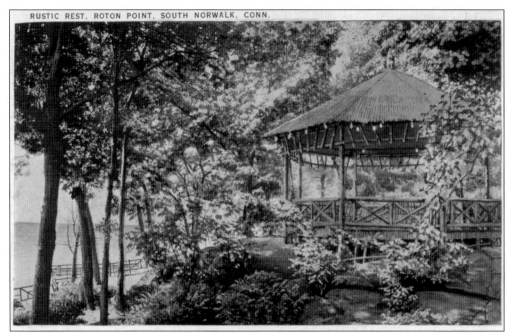

This image shows the gazebo, as seen from the hotel porch. Built in the 1920s atop the rock outcropping, the gazebo, at the highest point in the grove, offers visitors an opportunity to capture cool summer breezes, as well as beautiful water views. (Courtesy of Lisa Wilson Grant.)

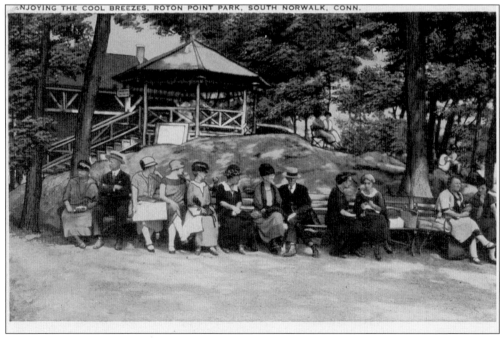

The gazebo also served as a bandstand. The sign leaning against the structure probably posted the name of the band or schedule. Often, bands came up on the steamships and played afternoon concerts in the grove. The hotel is in the background. (Courtesy of the Robinson family.)

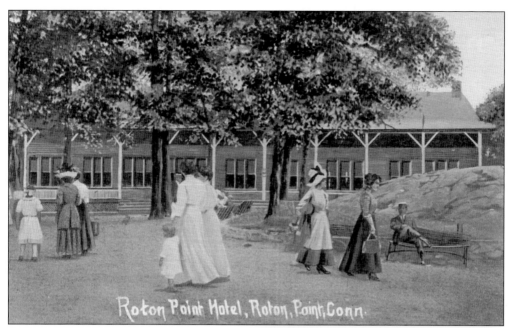

Roton Point Hotel, Roton, Point, Conn.

Ladies and children are enjoying the grove with the hotel in the background. Later, the hotel porch would be the site of vaudeville shows, juggling acts, and dog shows. (Courtesy of the Simmons family.)

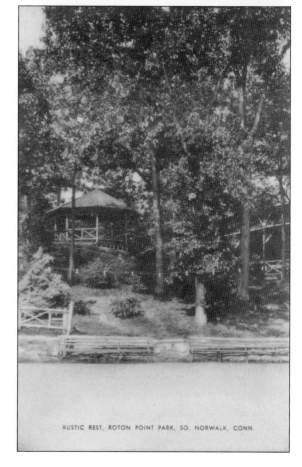

RUSTIC REST, ROTON POINT PARK, SO. NORWALK, CONN.

The gazebo was a popular place for bands to play, as the music could carry far and wide at the park. This view is facing uphill from the bathhouse area. (Courtesy of the Simmons family.)

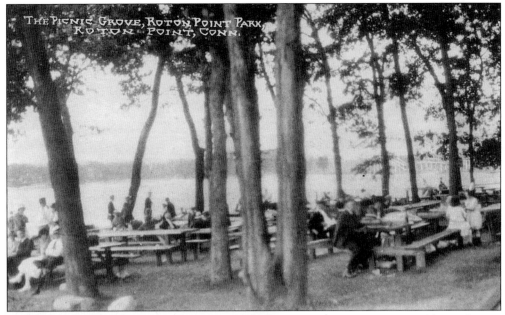

Shown here are picnic tables in the shady grove at Roton Point, with Long Island Sound in the background. (Courtesy of the Simmons family.)

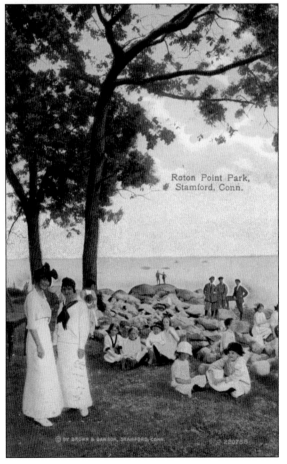

Visitors are enjoying sea breezes among the rocks of the lower grove. This postcard erroneously places Roton Point in Stamford, Connecticut. (Courtesy of Lisa Wilson Grant.)

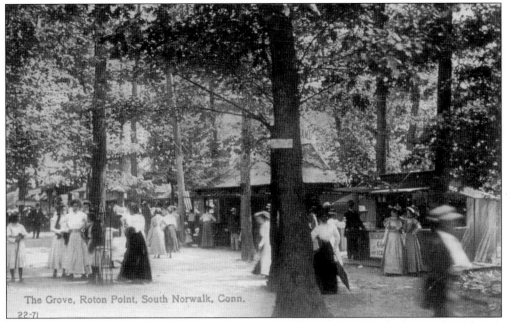

The Grove, Roton Point, South Norwalk, Conn.
22-71

Turn-of-the-20th-century visitors are enjoying the concessions, including the ice cream booth at right, in the shade of the grove. (Courtesy of the Simmons family.)

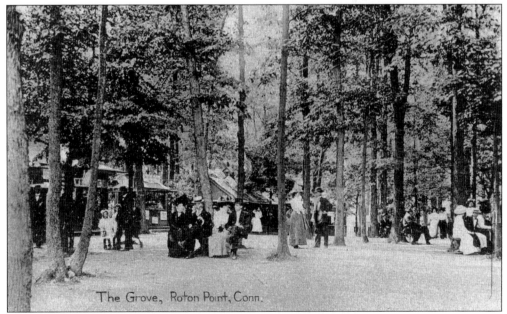

The Grove, Roton Point, Conn.

This view of the grove shows several concessions nestled among the trees in the background. Benches surrounding or alongside the trees gave parkgoers a comfortable place to enjoy the shade. (Courtesy of the Simmons family.)

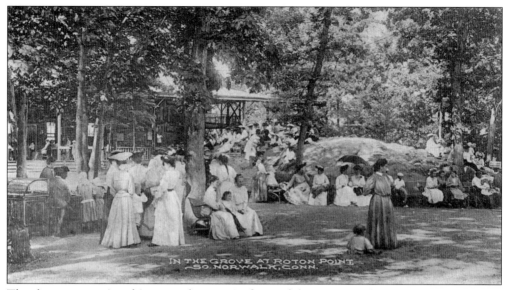

The three persons in white, seated center in front of the tree, are, from left to right, Jennie Bradbury, Edna Bradbury Rowan, and Sarah Upson. They lived on Bayview Avenue in South Norwalk and were the grandmother, mother, and great-grandmother of current Roton Point Association member George Rowan. (Courtesy of the Simmons family.)

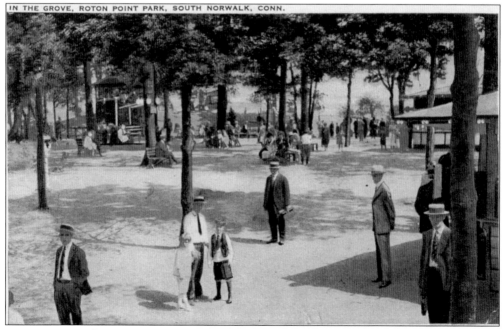

Roton Point Park enjoyed a reputation for always being clean and tidy. The sale of beer and liquor was discontinued long before prohibition; gambling and rowdyism were not tolerated. It was an especially pleasant place to take the family. (Courtesy of the Robinson family.)

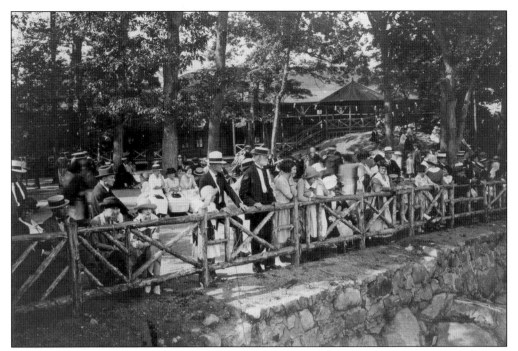

Visitors admire the antics of beachgoers while enjoying the shade along the wooden fence that lines the grove. The fence is of the same rustic cedar construction as the gazebo, a look that was popular throughout the country in many parks. (Courtesy of the Robinson family.)

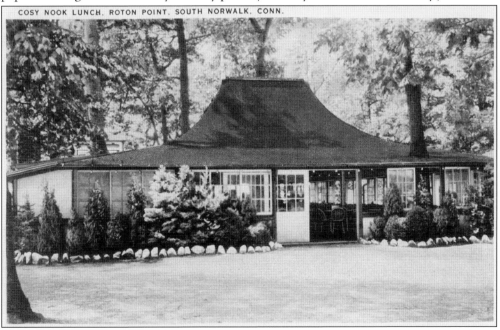

The Cosy Nook lunchroom was located in the grove. According to a 1938 advertising brochure, it was a "lunchroom for ladies and gentlemen who prefer some of this and that, moderately priced, instead of table d'hote dinner. Quality and service are on par with the Casino." (Courtesy of the Robinson family.)

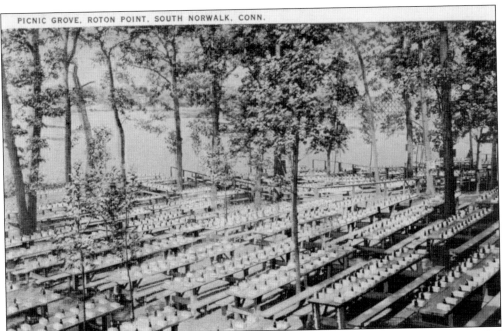

The 1938 advertising brochure boasted that "the heart of Roton Point Park is a thickly-wooded grove whose tables accommodate 3,000 men, women and children . . . The management will, whenever possible, gladly reserve enclosed grove sections for picnic parties." The pictures above and below, taken from the same focus, show part of the grove before and during a children's picnic. (Courtesy of Lisa Wilson Grant.)

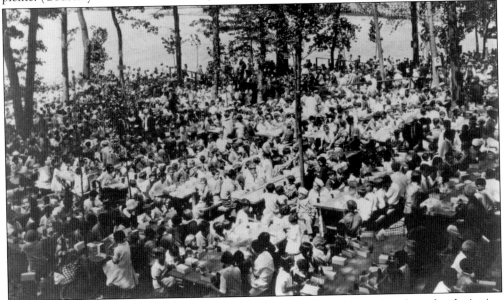

Roton Point attracted numerous church and fraternal organizations, Sunday school picnics, lodge outings, conventions, marching and chowder societies, band concerts, and weeklong festivities sponsored by the Reliance Hook and Ladder Company boys of Rowayton. The grove accommodated them all and provided box lunches when requested. (Courtesy of Roton Point Archives.)

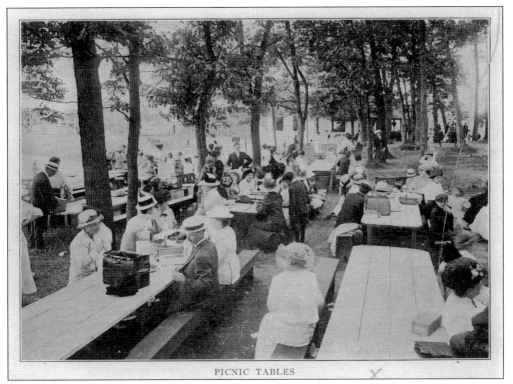

PICNIC TABLES

In 1915, the advertising brochure reinforced that "it is the purpose of this resort to be an outing place for families, especially women and children, and their comfort and safety is the paramount consideration," as the park before that time may have had a less wholesome reputation. (Courtesy of the Robinson family.)

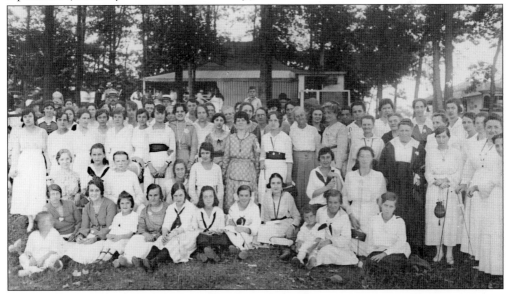

Seen here, employees of the American Fabric Company enjoy their summer excursion at Roton Point. Most likely their lunch would have been provided by the Cosy Nook lunchroom located immediately behind them. (Courtesy of the Robinson family.)

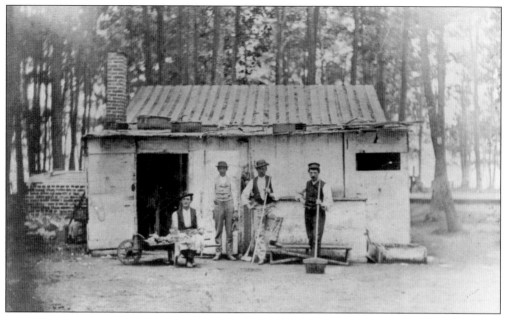

The Cook House is seen here in 1875. In a *New York Times* article, the Schnorer Club, "made straight for Herr Ackert's pavilion, . . . (where they) were steaming thousands of clams, dozens of chickens, scores of frog's legs and similar delicacies . . . they soon seated at the tables, the moss was thrown off from the clambake, and (they) attacked it valorously, struggled bravely for an hour, and vanquished it utterly . . . when they came away in the evening there was nothing left . . . save clam shells and chicken bones." (Courtesy of Roton Point Archives.)

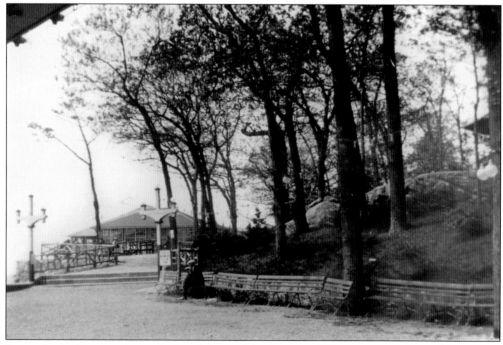

From the bathhouse along the beachfront, this shows a different perspective of the grove, looking up from the beach area. (Courtesy of Roton Point Archives.)

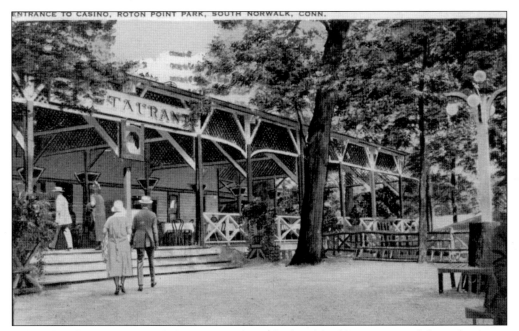

Pictured is the restaurant and dining veranda in the hotel building as viewed from the grove. One could dine alfresco on the veranda, which was open to the sea breezes. (Courtesy of the Simmons family.)

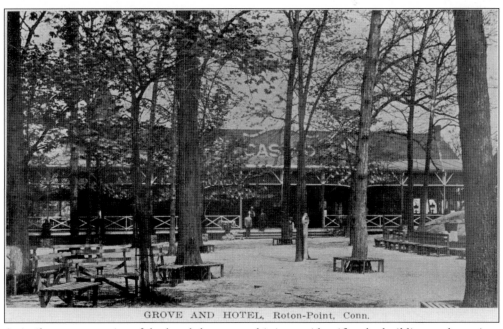

GROVE AND HOTEL, Roton-Point, Conn.

A similar vantage point of the hotel, however, this image identifies the building as the casino. (Courtesy of Lisa Wilson Grant.)

43

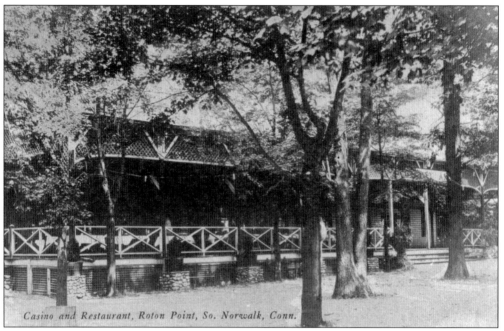

Casino and Restaurant, Roton Point, So. Norwalk, Conn.

This postcard image of the casino and restaurant provides a close up of the building's interesting architectural elements and stone planters. (Courtesy of the Simmons family.)

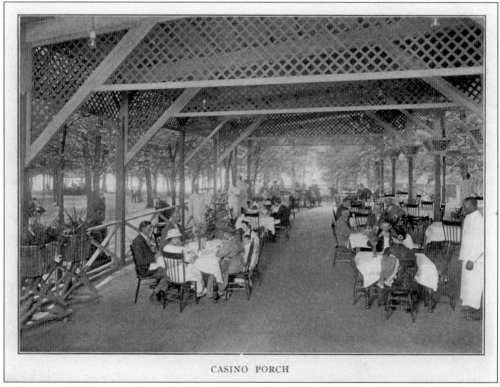

CASINO PORCH

The 1915 Roton Point Park brochure bragged that "nowadays a real restaurant in a park is a rarity. The Casino has a seating capacity of 1,000 diners." (Courtesy of the Robinson family.)

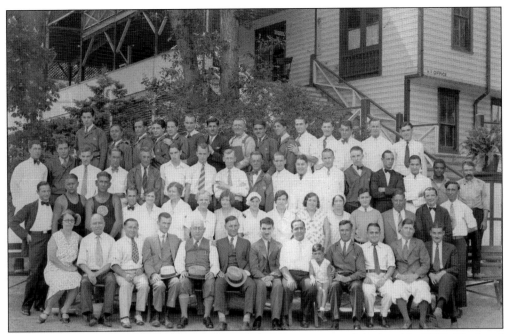

All dressed up, Roton Point staff poses on the side entrance steps of the hotel in 1930. The hotel kitchen is at the top of the stairs behind them; to the right of the kitchen entrance, a second set of double doors (to nowhere) gives evidence of the frequent changes made through the years to the hotel building. (Courtesy of the Robinson family.)

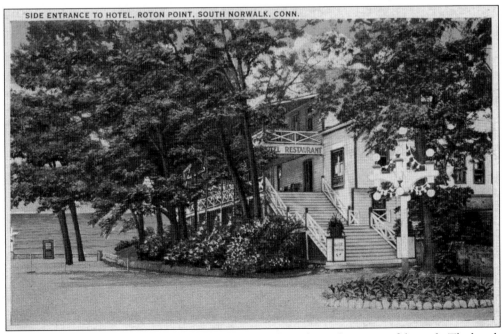

The side entrance of the hotel and restaurant are seen from the midway area of the park. The beach is to the left of the image, offering a perspective of how close the hotel actually is to the water. Again, the beautiful landscaping is evident in this view. (Courtesy of the Robinson family.)

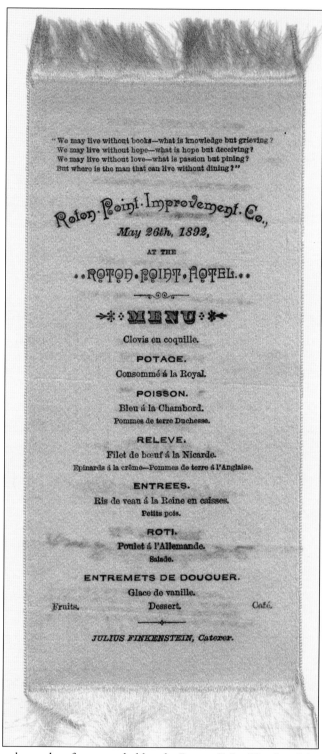

"We may live without books—what is knowledge but grieving?
We may live without hope—what is hope but deceiving?
We may live without love—what is passion but pining?
But where is the man that can live without dining?"

Roton Point Improvement Co.,

May 26th, 1892,

AT THE

..ROTON POINT HOTEL..

✳ MENU ✳

Clovis en coquille.

POTAGE.

Consommé á la Royal.

POISSON.

Bleu á la Chambord.
Pommes de terre Duchesse.

RELEVE.

Filet de bœuf á la Nicarde.
Epinards á la crême—Pommes de terre á l'Anglaise.

ENTREES.

Ris de veau á la Reine en caisses.
Petits pois.

ROTI.

Poulet á l'Allemande.
Salade.

ENTREMETS DE DOUOUER.

Glace de vanille.

Fruits. Dessert. Café.

JULIUS FINKENSTEIN, Caterer.

A lovely silk menu, keepsake of an event held at the Roton Point Hotel on May 26, 1892, is seen above. (Courtesy of the Simmons family.)

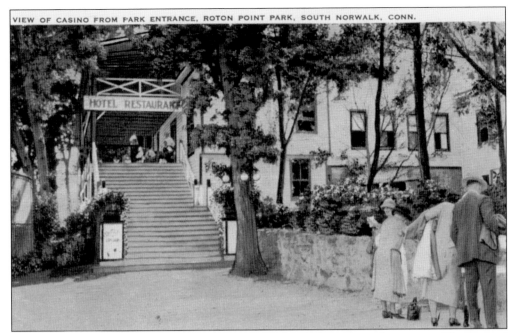

This card depicts the entryway to the hotel and restaurant from the park entrance. The covered balcony above the "Hotel Restaurant" sign was accessed through the relatively large hotel room at the end of the upstairs hall. The tree at the base of the steps was still there decades later but was finally taken down in the early 2000s. (Courtesy of Lisa Wilson Grant.)

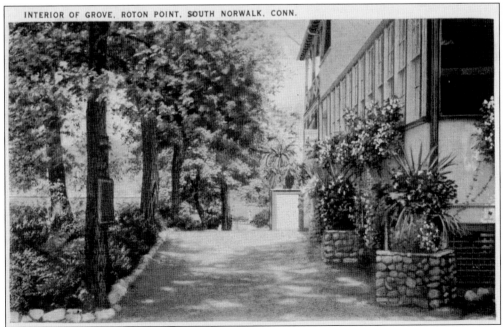

INTERIOR OF GROVE, ROTON POINT, SOUTH NORWALK, CONN.

Above is an interior view of the grove alongside the hotel building, illustrating the fine landscaping and pristine grounds for which Roton Point Park was known. (Courtesy of the Simmons family.)

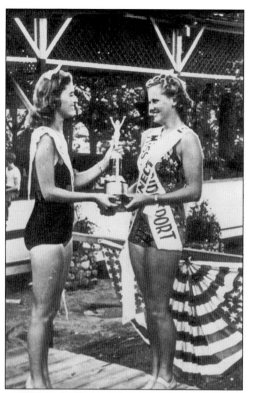

Bathing Beauty contests were popular at Roton Point. Here, Miss Bridgeport is being selected as Miss Connecticut and is crowned at Roton Point before advancing to Atlantic City, New Jersey. (Courtesy of Roton Point Archives.)

In 1933, at the age of 15, Marion Bergeron of West Haven won the Miss Connecticut title at Roton Point and was later crowned Miss America in Atlantic City, thus being the first Connecticut Miss America. She is depicted here with her entourage in robes designed and created by Rabhor Robes of South Norwalk. Peter Palladino, in the white suit to the right of the stage, has descendents who are members of Roton Point today and kindly provided this picture. He reportedly designed these robes while an employee at Rabhor. (Courtesy of the Palladino family.)

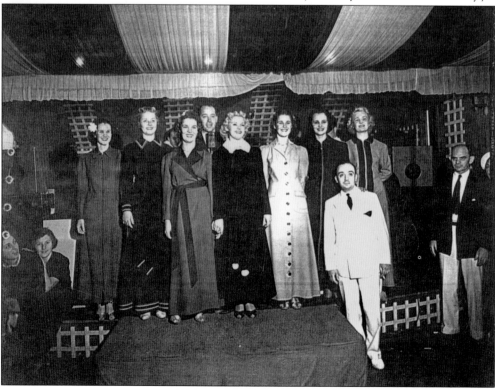

Three

DANCING ON THE SHORE

One of the central attractions at Roton Point Park was the 7,500-square-foot dance pavilion, built out over the rocks on the Long Island Sound shoreline. Over the years, postcard images show this structure becoming more elaborate, eventually even including a small addition to the side that housed a refreshment counter.

According to Roton Point Park's 1915 season brochure, "the pavilion is situated directly over the waters of the Sound and open on all sides to the cooling breezes. A specially trained orchestra supplies the music and during the afternoons excursionists and picnickers are permitted to dance free of charge."

One of the many stops for big bands of the day, Roton Point's dance pavilion played host to a summertime parade of top acts, including Bunny Berigan, Cab Calloway, the Dorsey Brothers, Eddy Duchin, Duke Ellington, Benny Goodman, Wayne King, Guy Lombardo, Jimmie Lunceford, Glenn Miller, Rudy Vallee, Fred Waring, and more. These performers would typically play Sunday nights from 8:15 p.m. to 11:30 p.m. and attracted a large, enthusiastic audience.

One example of the pavilion's lasting musical influence: in his autobiography, hard bop jazz legend Horace Silver, perhaps best known for "Song for My Father," talks about growing up in Norwalk and traces his decision to become a professional musician to a single night when he was 11 years old and convinced his father to stay late at Roton Point to hear Jimmie Lunceford and his orchestra play.

After being weakened considerably in the 1938 hurricane, the pavilion became unstable and was eventually dismantled in 1943. Across the rocks today, there may still be seen drilled holes and concrete circles, weather-beaten traces of the many pilings that once supported the rollicking reveries of the Roton Point dance pavilion.

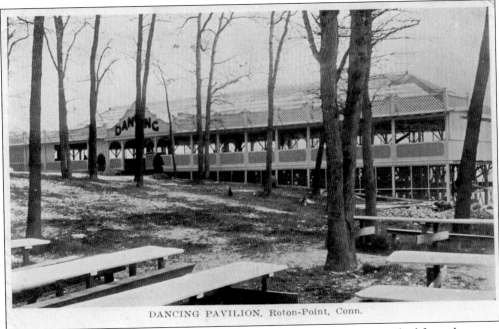

DANCING PAVILION, Roton-Point, Conn.

Dancing was one of the delightful features at Roton Point. Often photographed from the water, this postcard shows a rare view of the dance pavilion as seen from the grove. (Courtesy of the Simmons family.)

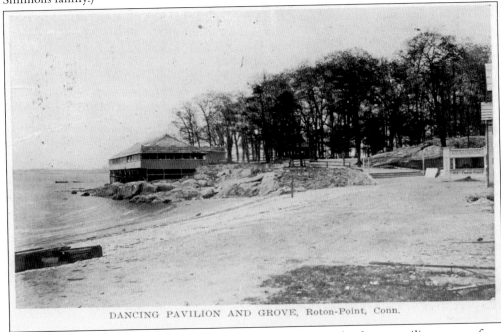

DANCING PAVILION AND GROVE, Roton-Point, Conn.

This unusual and potentially off-season postcard image shows the dance pavilion as seen from the end of East Beach prior to the stone seawall being built along the shorefront. Some of the grove's concession buildings are visible nestled in the trees, and over on the right side of the image are the edges of the bathhouse and the beginning of some of the midway concessions. (Courtesy of the Simmons family.)

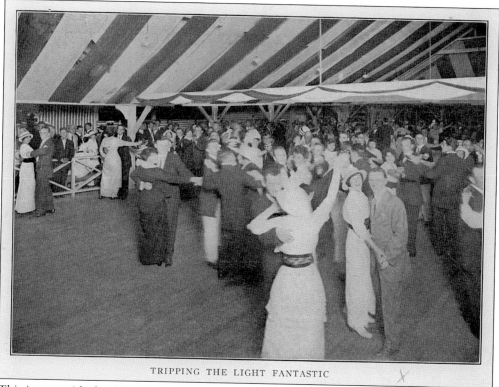

TRIPPING THE LIGHT FANTASTIC

This image with the delightful caption, "tripping the light fantastic," is taken from the 1915 Roton Point Park brochure depicting the 7,500-square-foot space crowded with enthusiastic dancers. (Courtesy of the Robinson family.)

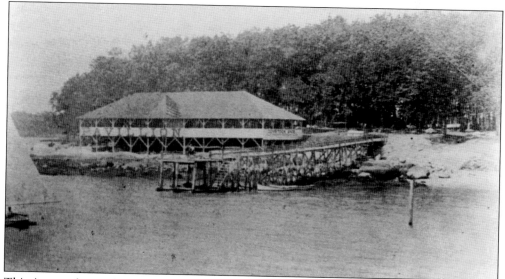

This image shows the dance pavilion sometime around 1875, including a dock that was subsequently removed when the larger steamboat pier was constructed at the end of Pine Point. (Courtesy of the Robinson family.)

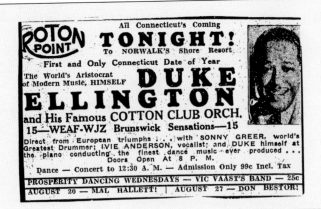

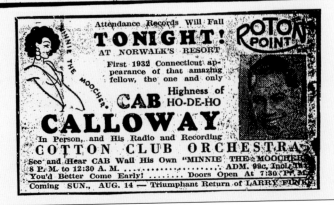

Shown here are advertisements for Duke Ellington, Cab Calloway, and the Famous Cotton Club Orchestra. (Courtesy of Stan Pastore.)

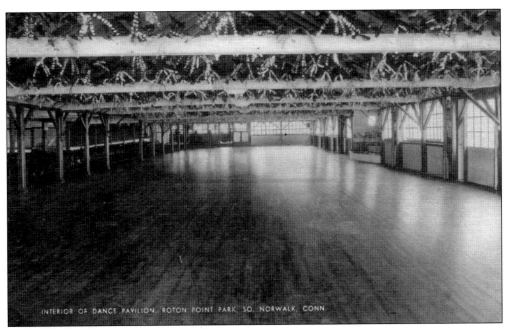

INTERIOR OF DANCE PAVILION, ROTON POINT PARK, SO. NORWALK, CONN.

This interior view of the dance pavilion illustrates what an expansive space it truly was. According to Judge Stanley Mead, the floor was maple and in the summer was open on all sides so dancers could enjoy the summer sea breezes. (Courtesy of the Robinson family.)

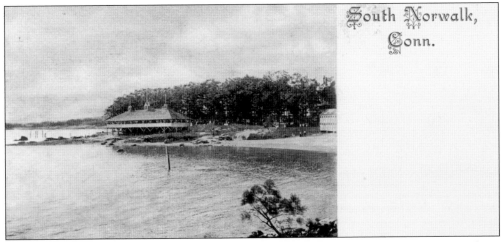

South Norwalk, Conn.

Daytime picnickers were sometimes allowed to sit in the dance pavilion, but it was primarily an evening feature of the park. (Courtesy of the Simmons family.)

53

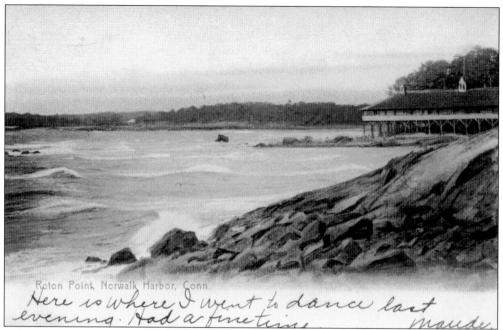

Roton Point, Norwalk Harbor, Conn.

Here is where I went to dance last evening. Had a fine time. Maude.

What a lovely place it must have been to dance on a summer evening, as the pavilion was situated on stilts over the rocks. Maude sent this card to boast of her fun dancing at the pavilion. (Courtesy of the Simmons family.)

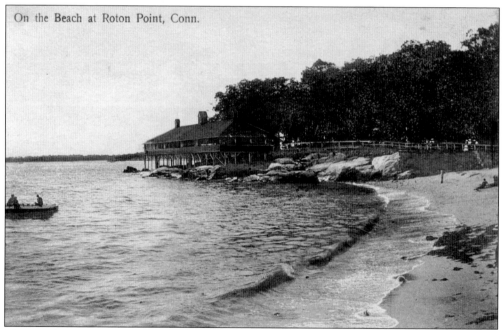

On the Beach at Roton Point, Conn.

The Sunday night dances provided local residents a wonderful place to meet people; many marriages had their start with a first meeting at a dance at Roton Point. (Courtesy of Lisa Wilson Grant.)

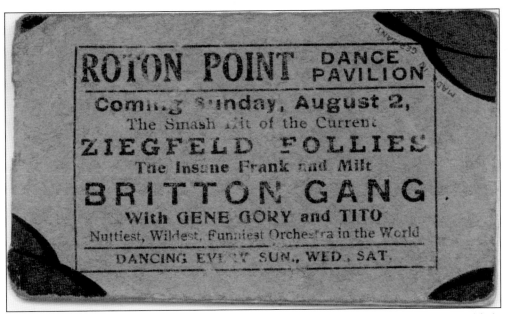

This is the cover image of a small booklet (roughly 3.5 by 2 inches) of blank pages, most likely for signatures of the famous bandleaders that entertained the crowds at the dance pavilion. (Courtesy of the Simmons family.)

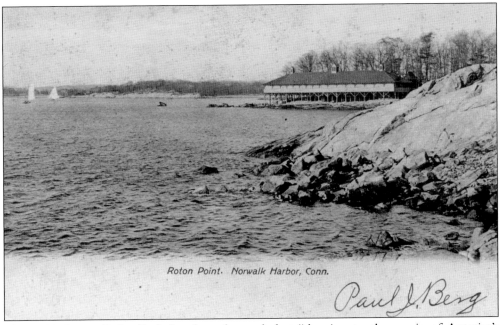

The 1938 Roton Point Park brochure boasted that "dancing to the music of America's greatest orchestras, and gala fireworks display are among the evening features." (Courtesy of Lisa Wilson Grant.)

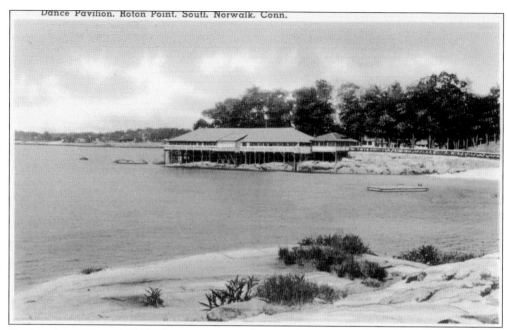

During the 1920s and 1930s, it was common for popular bands to make personal appearances in dance halls and amusement parks. Roton Point was no exception, featuring big band names every Sunday night at the dance pavilion. (Courtesy of Lisa Wilson Grant.)

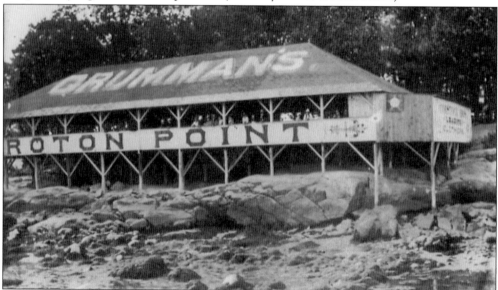

At times, advertisers would add their brand name to the pavilion roof. Grumman's Bottling Works, established in 1844, originally used Norwalk Pottery clay bottles. One of its products, Olden Time Root Beer, was touted for its "beneficial effect upon the nervous, digestive system." Roton Point had its own glass bottles, which may have been bottled by Grumman's at one time. A few glass bottles have recently been discovered during excavating work on-site, which contain the embossing "Roton Point Park" on one side and "This bottle not to be taken from the park" on the other and were bottled by Schueler of Stamford, Connecticut. (Courtesy of Roton Point Archives.)

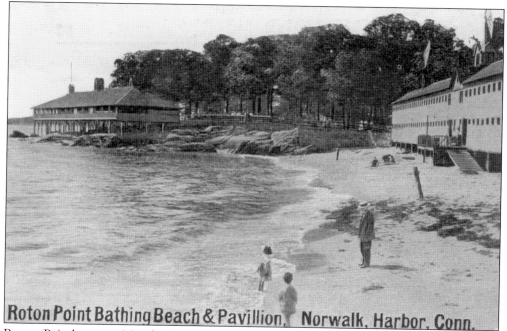

Roton Point Bathing Beach & Pavillion, Norwalk, Harbor, Conn.

Roton Point's enterprising booking agent, Leo Miller, did not disappoint the thousands of patrons who would turn out to hear their favorite performers. The largest attendance at the dance pavilion came in the 1930s, when Rudy Vallee appeared with Alice Faye, overfilling the pavilion with 1,800 people. Reportedly, 10,000 more jammed the entire park outside just to catch a peek. (Courtesy of Lisa Wilson Grant.)

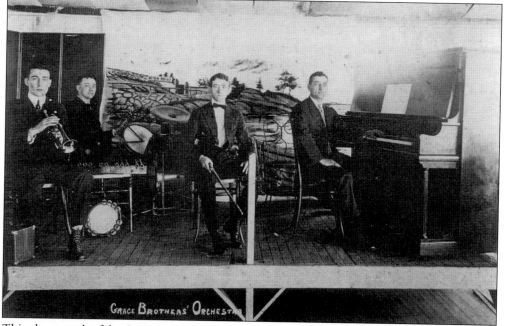

GRACE BROTHERS' ORCHESTRA

This photograph of the Grace Brothers Orchestra taken on the stage in the dance pavilion shows a hand-painted mural backdrop of Sunset Rock and the walkway from the pier. (Courtesy of Roton Point Archives.)

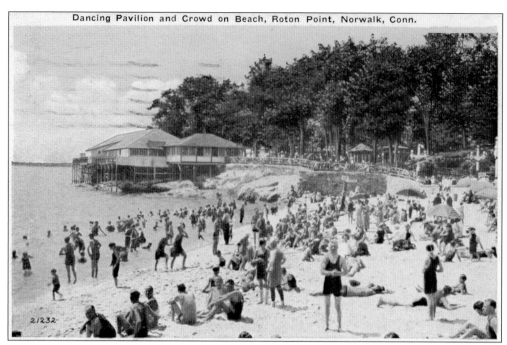

This image shows the dance pavilion from the far end of East Beach, with a crowded beachfront and shady grove in the background. (Courtesy of the Simmons family.)

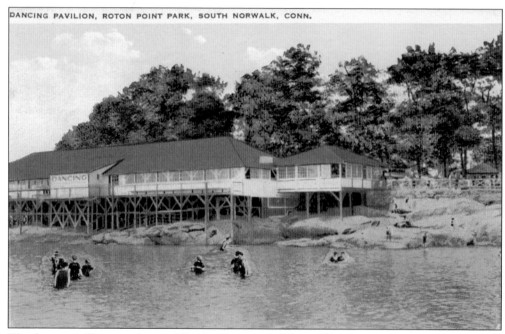

The dance pavilion was also used for dancing competitions. The Great Depression spawned the short-lived fad of dance competitions for cash prizes for the couple that could dance the longest, sometimes hanging on for days until they literally dropped to the floor in a heap of exhaustion. (Courtesy of Lisa Wilson Grant.)

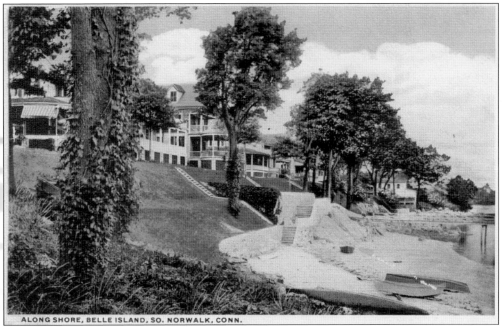

ALONG SHORE, BELLE ISLAND, SO. NORWALK, CONN.

Mrs. Hickey ran the Soundview Hotel, which had a 30-person limit. Notable bandleaders such as Guy Lombardo and Tommy Dorsey were known to stay at the Soundview while performing at Roton Point. (Courtesy of Lisa Wilson Grant.)

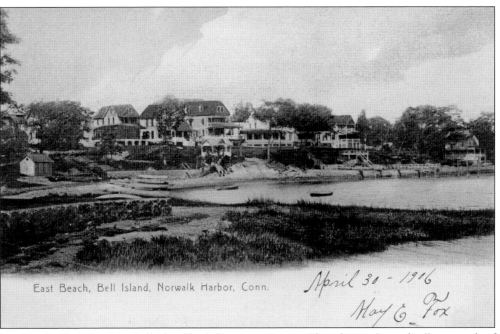

East Beach, Bell Island, Norwalk Harbor, Conn. April 30 - 1916 May 6 Fox

During the Roaring 20s, Bell Island had the reputation as a "bootleggers' paradise" as a result of a New York newspaper article about Prohibition in Rowayton. According to the reports, booze flowed like water and speedboats powered around late at night making deliveries. (Courtesy of Lisa Wilson Grant.)

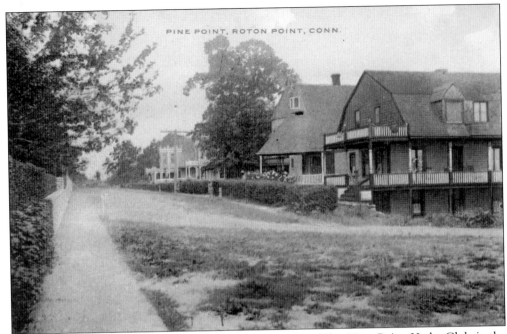

PINE POINT, ROTON POINT, CONN.

Pine Point is the neighboring area east of Roton Point. The Pine Point Yacht Club is the building in the foreground. (Courtesy of Lisa Wilson Grant.)

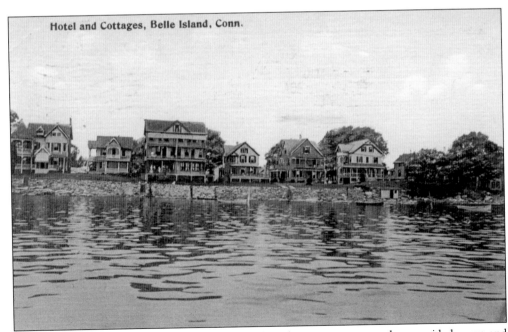

Hotel and Cottages, Belle Island, Conn.

Neighboring Bell Island was host to nearby hotels and summer cottages that provided room and board for many of the orchestras, as well as Roton Point visitors. (Courtesy of Lisa Wilson Grant.)

Four

FUN IN THE SUN

It is very difficult to resist the allure of a sandy beach with pleasant waves crashing upon it. From the start, the beaches at Roton Point offered visitors this very opportunity to swim and play in the usually gentle surf of Long Island Sound. South-facing crescent-shaped beaches nestled between the rock outcroppings slope easily into the water, providing ideal swimming conditions for swimmers of all ages and skills. Even for those visitors who did not dive in, time on the beach must have been a welcome change from the usual daily routine.

Roton Point Park would rent swimmers a bathing suit and a changing stall and also offered an anchored float to swim out to and a diving platform beyond that. Throughout it all, lifeguards would row their small boat back and forth to assure nervous parents on the beach. On October 3, 1910, a *New York Times* article reported that the Roton Point crew won the US Life Saver's Annual Dory Contest, a 10-mile row, in 1908 and again in 1910.

Out beyond the fun and frolic of sandy beaches, there has always been a need for lighthouses in Norwalk Harbor and the surrounding areas of Long Island Sound, dotted as they are with small islands, stone ledges, and water depths of all kinds. This need became even greater once the excursion steamer business to and from Roton Point picked up as the park became a popular destination.

Although the now-restored Sheffield Island Lighthouse can be seen from today's Roton Point breakwater and jetty, the only lighthouse readily visible from the Roton Point beach is Green's Ledge, its faithful beacon still changing from white to red to white again throughout the night.

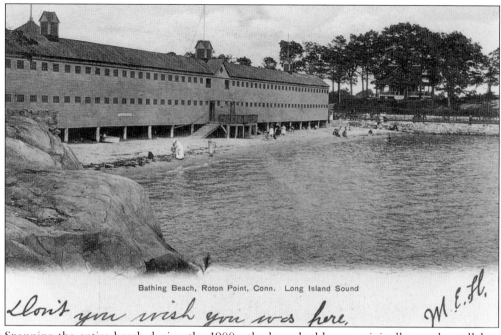

Bathing Beach, Roton Point, Conn. Long Island Sound

Don't you wish you was here, M.E.H.

Spanning the entire beach during the 1900s, the large bathhouse originally stood parallel to the shoreline. Later, it was cut in half and each "wing" was rotated perpendicular to the beach, flanking the octagonal building that remained in the center. (Courtesy of Lisa Wilson Grant.)

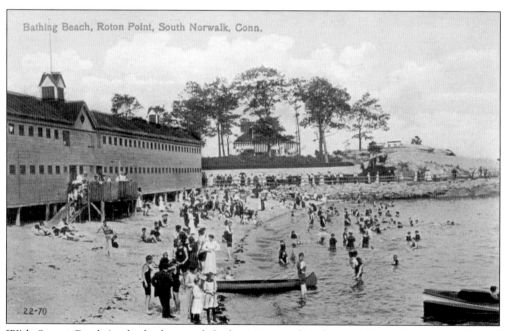

Bathing Beach, Roton Point, South Norwalk, Conn.

22-70

With Sunset Rock in the background, bathers in rented, itchy, woolen swimsuits smelling of disinfectant somehow enjoy their day at the beach. The open feeling of the beach area would be improved once the large bathhouse building was reconfigured. (Courtesy of Lisa Wilson Grant.)

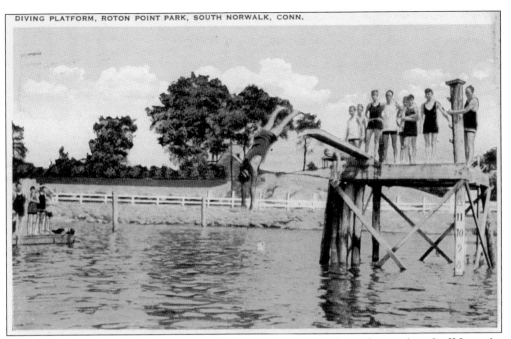

Taking a dive, these youngsters show off a little as they enjoy themselves and cool off from the hot summer sun. This early diving platform was later replaced with moored floats, similar to those that are still in use at Roton Point today. (Courtesy of Lisa Wilson Grant.)

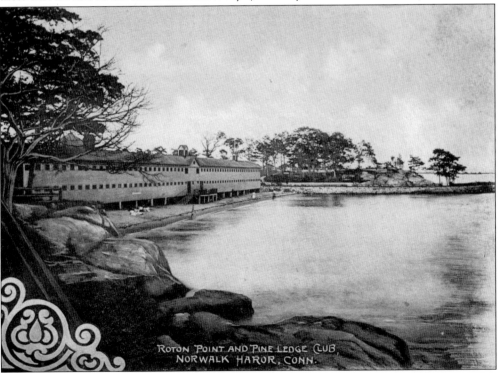

ROTON POINT AND PINE LEDGE CLUB, NORWALK HAROR, CONN.

Another view of the long bathhouse that was later reconfigured is seen above. Note the Pine Ledge Club of Norwalk Harbor in the background. (Courtesy of the Robinson family.)

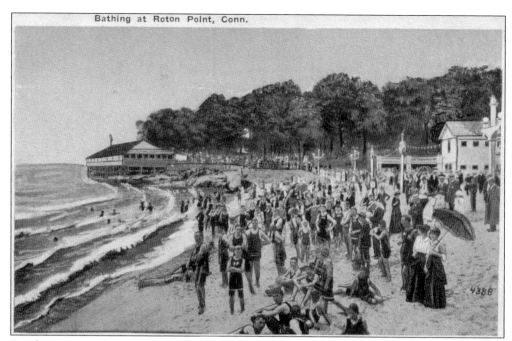

Beachgoers crowd the sand as others swim among the imaginatively retouched waves. This image shows the reconfigured bathhouse to the right and predates the stone seawall. In the back left, the dance pavilion seems to have sprouted a chimney, perhaps another retoucher flourish. (Courtesy of Lisa Wilson Grant.)

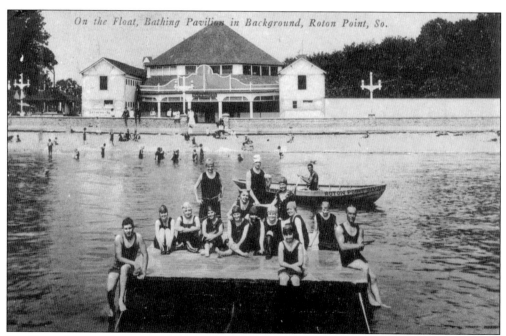

Just like today, people enjoyed swimming to the float and visiting. Note the dark bathing suits and bathing caps on the well-covered beachgoers. Several of the women even have bathing shoes. The rowboat belongs to Roton Point. (Courtesy of the Simmons family.)

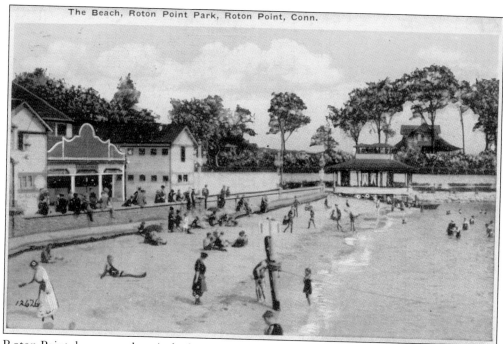

The Beach, Roton Point Park, Roton Point, Conn.

Roton Point drew crowds to its bathing beach and the many attractions that lined its shores. It also was a gathering place for churches and fraternal organizations, which held their picnics on the beautiful grounds. (Courtesy of the Simmons family.)

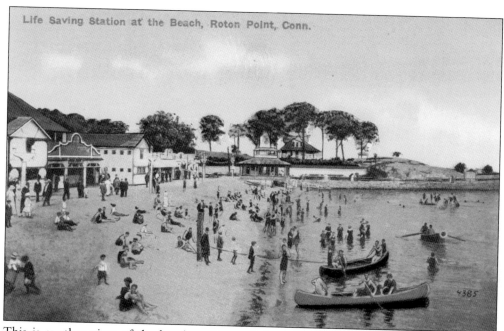

Life Saving Station at the Beach, Roton Point, Conn.

This is another view of the beach at Roton Point with its lifesaving station (center). The beach was a draw that attracted local families and excursion visitors as well. (Courtesy of the Simmons family.)

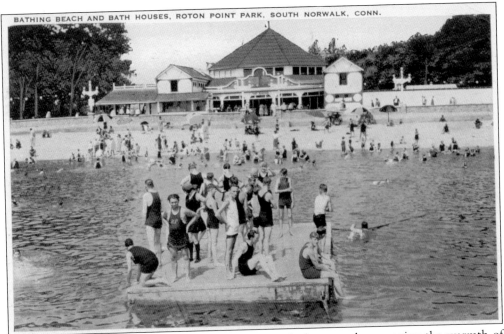

With the cool breeze coming off Long Island Sound, these gentlemen enjoy the warmth of the sun as bathers frolic with their families at the water's edge. The large building in the background is the reconfigured bathhouse. (Courtesy of the Simmons family.)

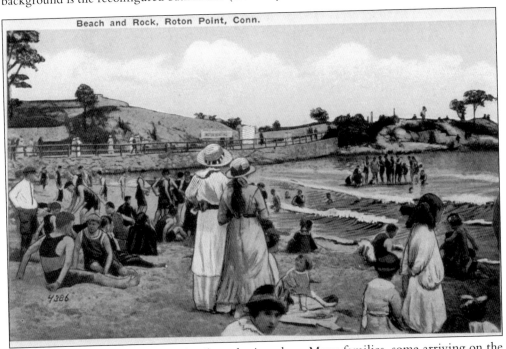

Beach and Rock, Roton Point, Conn.

Roton Point Park was a popular family gathering place. Many families, some arriving on the steam ferries from New York and surrounding areas, looked forward to enjoying a day at the shore with their children. The women were all attired in their best long dresses and beautiful hats to shade themselves from the sun. (Courtesy of the Simmons family.)

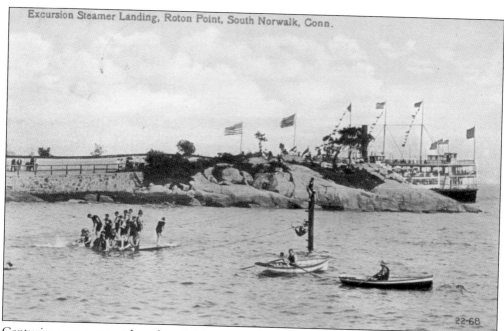

Excursion Steamer Landing, Roton Point, South Norwalk, Conn.

22-68

Centuries may come and go, but children are still enjoying themselves, jumping off floats and climbing pilings much as they did more than 100 years ago. Note the excursion steamer in the background pulling out at Roton Point. (Courtesy of the Robinson family.)

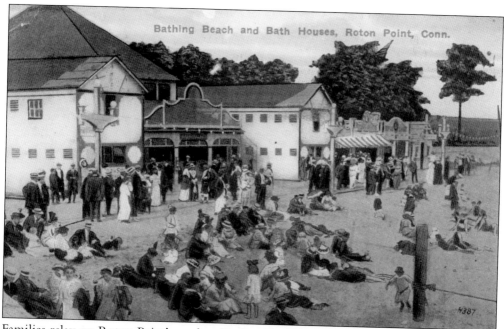

Bathing Beach and Bath Houses, Roton Point, Conn.

4387

Families relax on Roton Point's sand and enjoy the picturesque views. After a long day, the tall electric lampposts would light their way home at sunset. As always, everyone was properly dressed. (Courtesy of the Robinson family.)

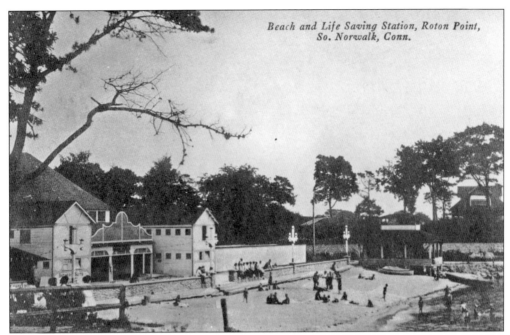

Beach and Life Saving Station, Roton Point, So. Norwalk, Conn.

By 1928, a stone seawall had been built between the bathhouse and the beach. The present-day octagonal center of the bathhouse was originally built to cover the first carousel but was also used as a vaudeville theater and, at one time, a roller-skating rink. (Courtesy of the Robinson family.)

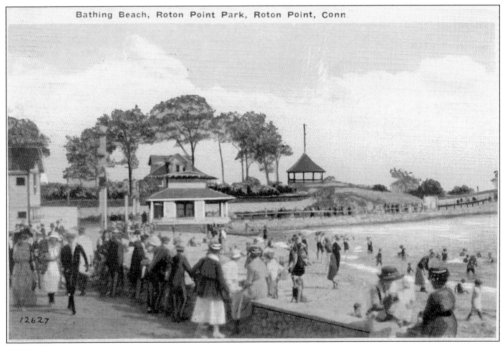

Bathing Beach, Roton Point Park, Roton Point, Conn.

The bathing beach at Roton Point sometimes served as a gathering place for many large groups and families that came on the ferry to enjoy the beauty and serenity of Roton Point. (Courtesy of the Simmons family.)

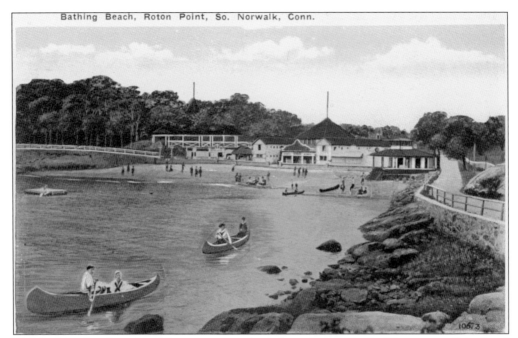

The bathing beach and bathhouse are seen here from Sunset Rock. The tower of the hotel is visible in the background. Canoeing in the bay was a popular activity that many families enjoyed on lazy, hazy summer days. (Courtesy of Lisa Wilson Grant.)

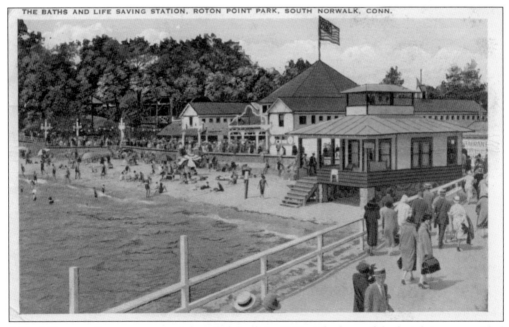

THE BATHS AND LIFE SAVING STATION, ROTON POINT PARK, SOUTH NORWALK, CONN.

A Red Cross station or emergency hospital, built in 1926 at the base of the hotel steps, provided first aid treatment and was outfitted with supplies for any emergency, according to a newspaper article of the day. Apparently, this supplemented the lifesaving station, seen here on the beach. (Courtesy of the Simmons family.)

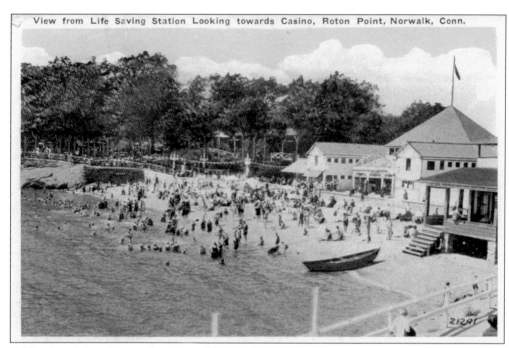

Taking the advice of many physicians of the day that exercise was a great stress reliever, many people began donning bathing suits—heavy woolen ones at that—and enjoyed the summer days swimming as others gathered at the edge of the grove to watch. (Courtesy of the Simmons family.)

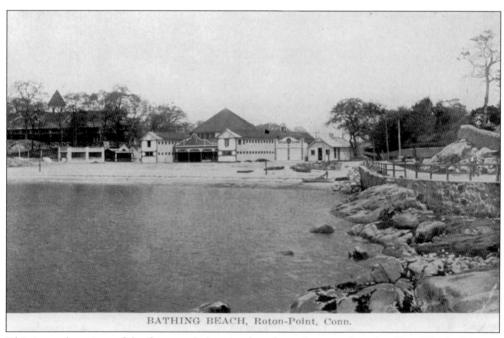

BATHING BEACH, Roton-Point, Conn.

This is another view of the fine, sandy beach taken from the steamboat landing. The bathhouse and concessions can be seen stretching along the East Beach, and on the hill to the left are the hotel and its tower. (Courtesy of the Simmons family.)

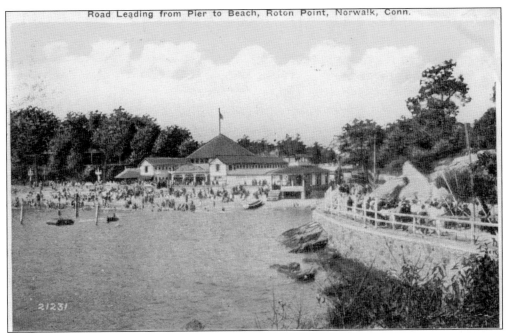

Road Leading from Pier to Beach, Roton Point, Norwalk, Conn.

Music, culture, and old-fashioned family values were all part of the familiar scene at Roton Point. Pictured above is the lifesaving station (at right), which was located there for just a short time. The newly reconfigured bathhouse can be seen at the center of the photograph. It is interesting to note the clothes on the people walking along the path to the beach. (Courtesy of the Simmons family.)

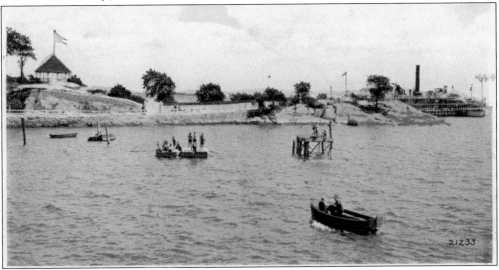

For those willing to give it a try, boats could be rented for the day and used along the sheltered cove of East Beach. In the background, left, is a gazebo on the grounds of the neighboring Pine Ledge Club. To the far right, a steamship is docked at the wharf; passengers disembarking from their ships would walk along the roadway to enter Roton Point Park. Although the Pine Ledge Club is long gone and replaced with private homes, Wharf Road remains and is still part of the present-day Roton Point Association. (Courtesy of the Simmons family.)

This real-photo postcard was taken from the edge of the grove facing toward West Beach on July 21, 1909. The miniature train ride that started from the grove can be seen in the distance traveling a route that would later be taken over by the roller coaster. (Courtesy of the Robinson family.)

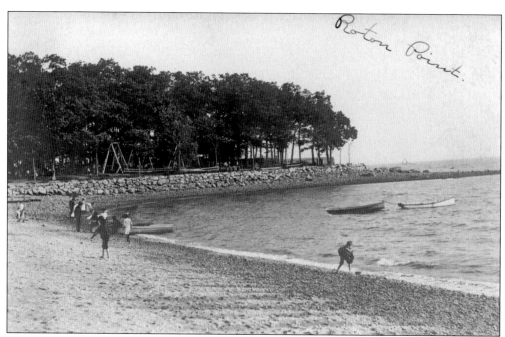

Another real-photo postcard looks across West Beach to the grove. In the distance is the children's playground, which was equipped with wooden juvenile amusement devices, including swings, slides, seesaws, and Maypoles. (Courtesy of the Robinson family.)

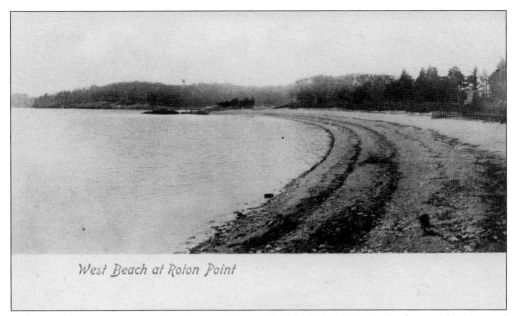

West Beach at Roton Point

A deserted view of West Beach at Roton Point with Price's Rocks in the background is pictured above. The roller coaster would have been along the beach to the right, and the grove would have been behind the viewer. Today, this beachfront is comprised of Wee Burn Beach Club and Bayley Beach. (Courtesy of the Simmons family.)

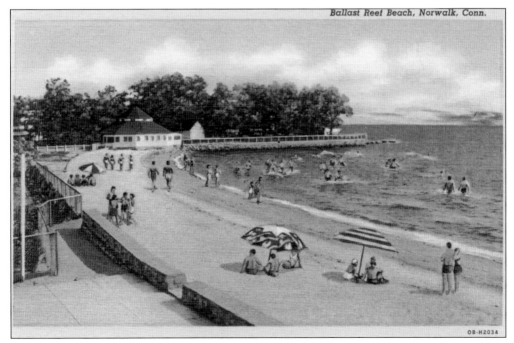

Ballast Reef Beach, Norwalk, Conn.

OB-H2034

This image shows fun in the sun at Ballast Reef Club, which today is Wee Burn Beach Club. Bathers take shelter under their beach umbrellas as others enjoy the cool water or walk on the sand. The carousel is the building in the distance. (Courtesy of Lisa Wilson Grant.)

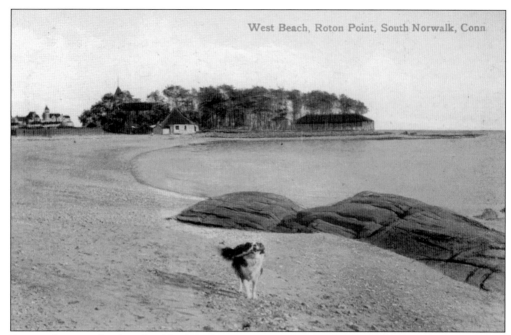

Deserted except for the adorable dog, this is another view of West Beach with the Roton Point buildings in the background. (Courtesy of the Simmons family.)

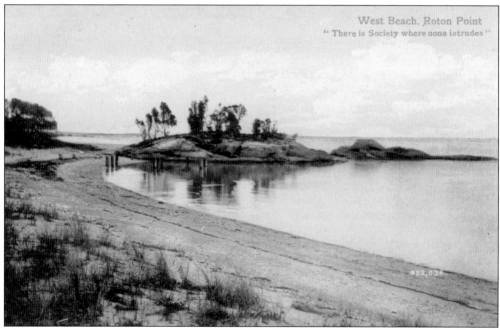

This image shows the west part of Roton Point on the other side of Price's Rocks. Once known as Columbus Grove, this area was primarily used as the beach for local residents. (Courtesy of the Simmons family.)

As the size and number of ships calling at Norwalk increased, additional navigational aids were needed. In 1896, the Lighthouse Board recommended that a caisson-style (sparkplug shaped) lighthouse be placed on Green's Ledge, at the western end of a long and dangerous shoal extending from Sheffield Island. The construction of Peck's Ledge Lighthouse just to the north of Sheffield Island was proposed at the same time, along with the placement of five post lanterns to mark the shipping channel in the harbor. (Courtesy of Lisa Wilson Grant.)

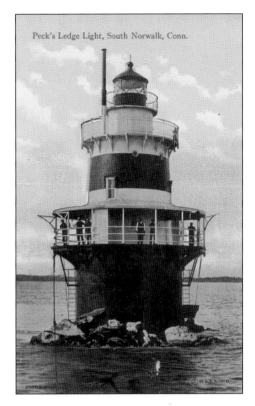

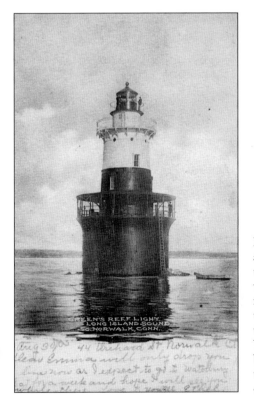

Legend has it that Green's Ledge was named after a pirate called Green, who sailed with the infamous Captain Kidd. When Green was captured by authorities of the day, he was reportedly executed and his body hung from the ledge in chains as a dire warning to others thinking of entering the buccaneering trade. Years later, the Green's Ledge Lighthouse would be established on the ledge as a safety warning to vessels entering Norwalk Harbor. (Courtesy of the Simmons family.)

75

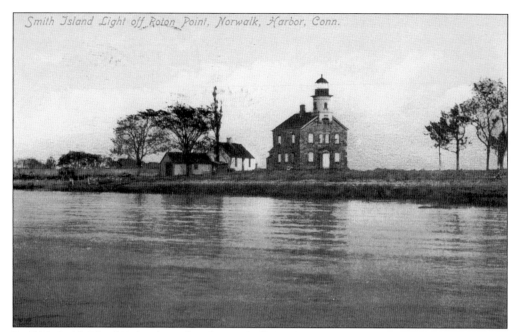

In 1826, Smith Island Light, also referred to as Sheffield Island, was illuminated by oil. Green's Ledge Lighthouse replaced this as Norwalk Harbor's eastern beacon. (Courtesy of the Simmons family.)

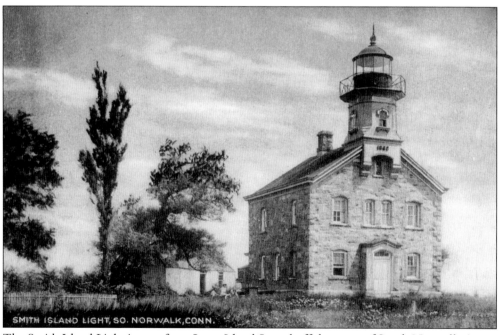

SMITH ISLAND LIGHT, SO. NORWALK, CONN.

The Smith Island Light is seen from Long Island Sound off the coast of South Norwalk; it was visible to visitors as they approached the pier at Roton Point. This building was originally a hotel, and the light was added later. Sheffield Island was used as an escape from cholera in the 1930s. (Courtesy of the Simmons family.)

76

Five

AROUND PINE POINT

Much of the coastline in Fairfield County, Connecticut, is taken up by large homes and estates, and yet—probably due to the presence of a rollicking amusement park—that was never the case in the Rowayton community immediately surrounding Roton Point.

The one notable exception was the next-door DeKlyn family summer residence, an eclectic assemblage of towers, porches, and verandas befitting a summer beach house. This home, abutting Roton Point and Bell Island on Pine Point, is visible in the background of some postcards and is even the focal point of others.

Pine Point, which is the eastern edge of the Roton Point property, was also where the 100-foot pier was built to accommodate the many incoming excursion boats, whose passengers would disembark and walk down what is now Wharf Road to arrive at their day at the beach.

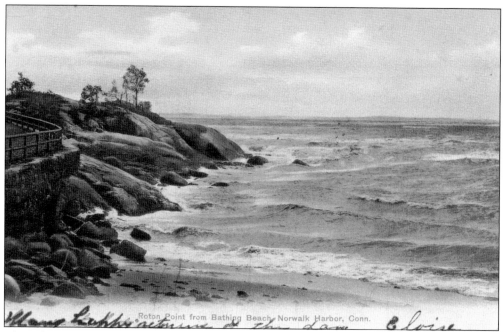

Roton Point from Bathing Beach, Norwalk Harbor, Conn.

This often-reproduced image shows the ebb tide along the rocky edge of Roton Point's East Beach as viewed from the shorefront. The steamship wharf would be just beyond Sunset Park, which is the center of this postcard. To the left is the fence along the road leading from the steamship wharf into Roton Point Park. (Courtesy of Lisa Wilson Grant.)

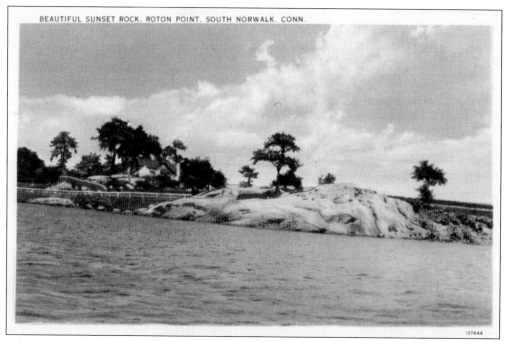

BEAUTIFUL SUNSET ROCK, ROTON POINT, SOUTH NORWALK, CONN.

A lovely sunset is pictured at the end of a beautiful day at the beach. Sunset Rock was named for both the pink granite in the rock itself, as well as how beautifully the light casts on it at sunset. (Courtesy of Lisa Wilson Grant.)

Looking from Sunset Rock at Roton Point, a photographer has artistically framed the beach between these two trees. The dance pavilion is on the left, with the bathhouse at right. (Courtesy of Lisa Wilson Grant.)

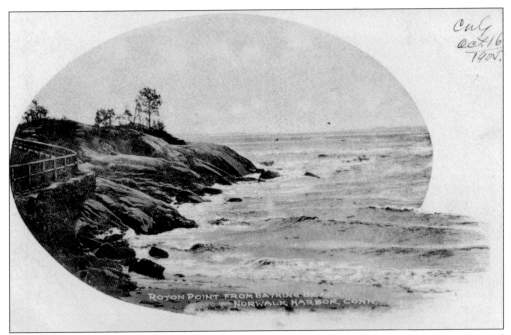

Visitors enjoyed strolling along this scenic path from the steamboat landing to the grove and amusement park. (Courtesy of Lisa Wilson Grant.)

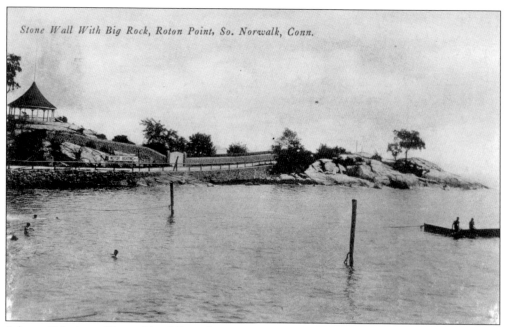

A beautiful view of Long Island Sound greets guests as they walk along the stone wall toward the big rock. Beneath a gazebo on the left, swimmers enjoy a summer's day in the water and on the float. (Courtesy of the Simmons family.)

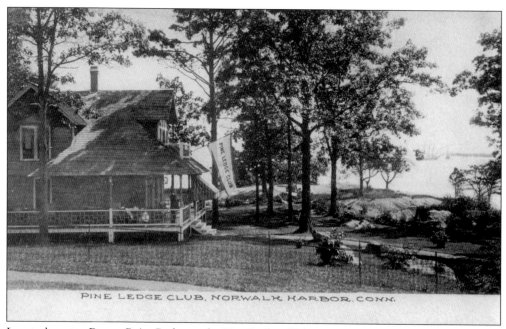

Located next to Roton Point Park was the Pine Ledge Club on Pine Point overlooking Norwalk Harbor. (Courtesy of the Simmons family.)

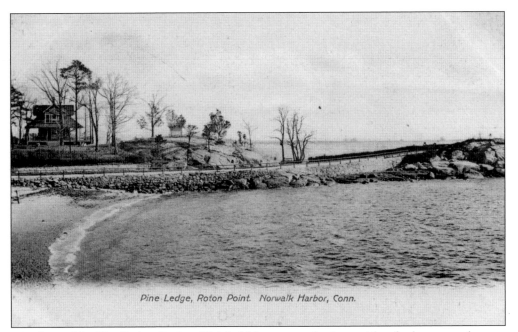

Pine Ledge, Roton Point. Norwalk Harbor, Conn.

Members of the Pine Ledge Outing Club held frequent gatherings with refreshments and games on the bluff at Pine Ledge. According to the *Norwalk Hour*, on one afternoon in 1894, "The ladies could be found playing whist (a card game) and at dusk the gentlemen joined them and 'partook of a hearty and tempting repast.'" (Courtesy of Lisa Wilson Grant.)

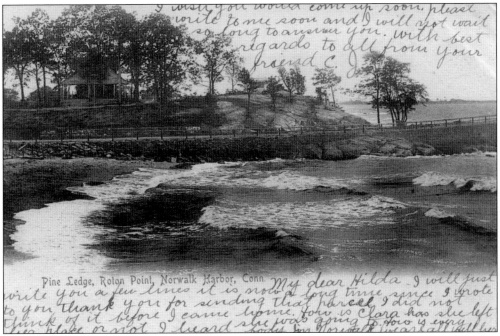

Pine Ledge, Roton Point, Norwalk Harbor, Conn.

Years later, the view on the same rock path is indicative of the changes in vegetation that beautify this lovely area. (Courtesy of Lisa Wilson Grant.)

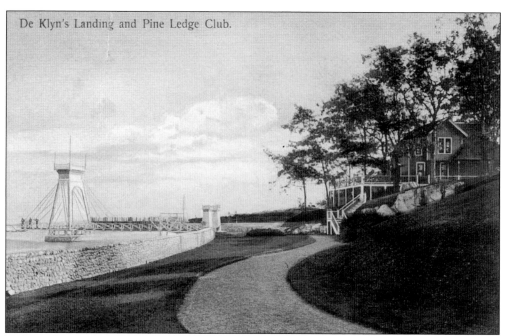

De Klyn's Landing and Pine Ledge Club.

On Pine Point, next to the Pine Ledge Club, was the DeKlyn family estate. The DeKlyn landing accommodated the family's two custom-built steam-powered yachts, *Nylked I* and *Nylked II*. (Courtesy of Lisa Wilson Grant.)

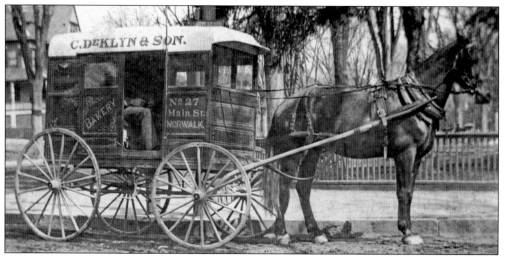

Charles DeKlyn accumulated his fortune as a baker and confectioner specializing in fancy ice cream, water ices, and frappes so rich and luscious that the mere thought of these concoctions caused mouths to water. He never failed to deliver, even on Sundays. (Courtesy of the Rowayton Historical Society.)

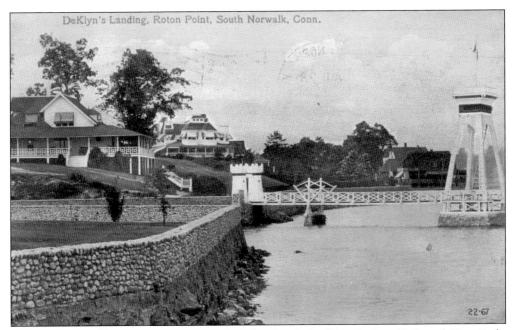

The DeKlyn estate bordered Roton Point's land and the Pine Ledge Club and Pine Park. Perhaps only a confectionery magnate such as DeKlyn would be agreeable to living right next to an active amusement park. The DeKlyns' private dock, featured prominently here, extended out in front of Bell Island's Crescent Beach. (Courtesy of the Simmons family.)

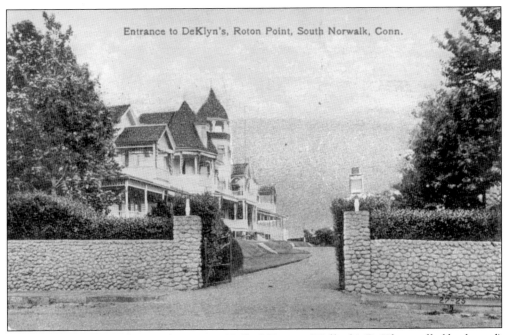

This is the entrance to the DeKlyn estate. Nylked Terrace (Nylked is DeKlyn spelled backward) shows the exact same stone masonry used on the walls visitors encountered as they arrived on Pine Point from the pier. (Courtesy of Lisa Wilson Grant.)

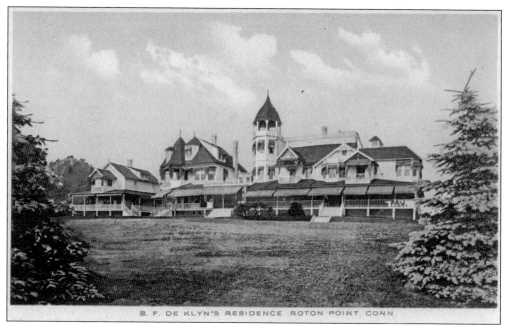

The DeKlyn residence was built by Dudley E. Hoyt, a descendent of earliest settlers, a Highland Avenue resident, and a local building contractor, who produced a number of cottages at Pine Point. Eventually, the main DeKlyn house was dismantled and separated into smaller residences; today, two are on Roton Avenue and the other is on Ensign Road. (Courtesy of Lisa Wilson Grant.)

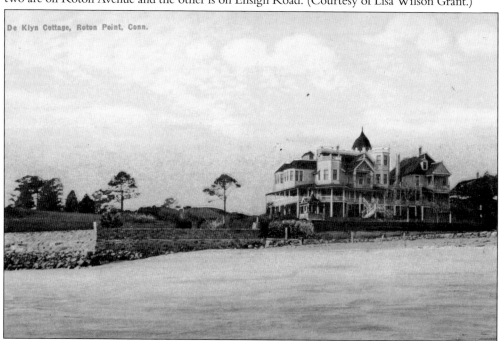

This grand estate was the DeKlyn family's summer cottage; their primary residence was in Danbury, Connecticut. Charles DeKlyn's birthday was on the Fourth of July, and there was always a magnificent fireworks display that everyone at Roton Point could see and enjoy. (Courtesy of Lisa Wilson Grant.)

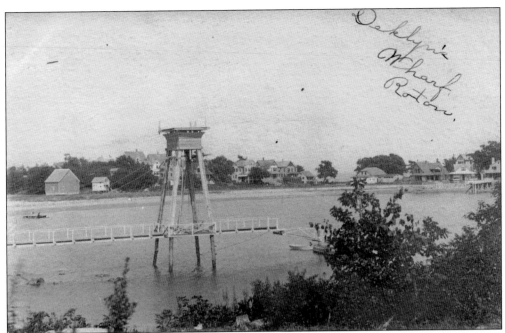

A real-photo postcard shows the DeKlyn wharf with Crescent Beach and Bell Island in the background. (Courtesy of the Robinson family.)

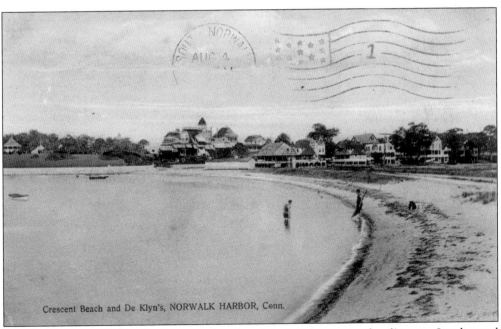

Crescent Beach and De Klyn's, NORWALK HARBOR, Conn.

Seen above are Bell Island's Crescent Beach and its bathhouses in the distance. Just beyond those, there was a narrow stone-walled passageway to Roton Point that went past the DeKlyn home and underneath a bridge on Nylked Terrace. The passageway, while still there, is closed off to pedestrians today. (Courtesy of the Simmons family.)

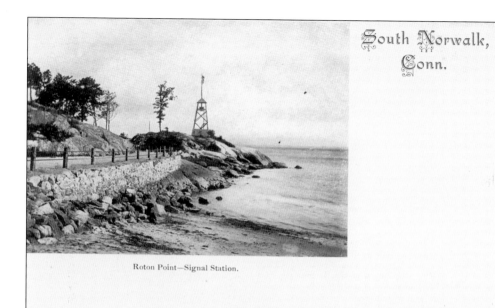

Roton Point—Signal Station.

Visitors enjoy the scenic walk along the cliff before entering the park. The beacon, which was a landmark for the steamships, included a bell atop the 40-foot tower; the bell was later used atop Rowayton Hose Company's first location in a boathouse at the foot of North Street in 1902. (Courtesy of the Simmons family.)

HOSE CO No 1,
ROWAYTON, CONN.

Benjamin DeKlyn gave the village the two-wheel pumper that was on his estate in 1902, as well as 600 feet of hose, as the Rowayton Hose Company was formed. In 1905, the Rowayton Hose Company erected its own building on Rowayton Avenue. In 1924, it merged with the Reliance Hook and Ladder Company but retained the name Rowayton Hose Company. (Courtesy of the Robinson family.)

Six

AMUSEMENTS FOR ALL

If the natural attractions of Roton Point Park were not quite enough, the park's management gradually expanded into offering other attractions such as midway games and booths to more thrilling and shriek-inducing rides. It was never the largest amusement park around and, by today's standards, might even seem charming, but in its day, there was certainly enough action to attract thousands to come experience the rides at Roton Point.

The park's beautiful carousel, situated nearly on the beach, was a favorite, with its Wurlitzer organ pumping and the waves crashing nearby at the same time. Through the years, there were three different roller coasters, all situated along West Beach. The first, the Tango Dip, was relatively gentle; it was lengthened in 1924 and renamed the Big Dipper. The final coaster, the Skylark, was installed in 1934—more compact, it offered a longer, faster, steeper ride.

Midway rides ranged from favorites like the Tumble Bug and the Ocean Wave Ferris wheel to bumper cars and an airplane-themed ride that must have given thousands of brave people their first taste of flying.

The arrival of Neville Bayley, with his background in amusement park rides and operations, was instrumental in creating and maintaining a good mix of attractions for all ages and in keeping Roton Point the "prettiest park on Long Island Sound."

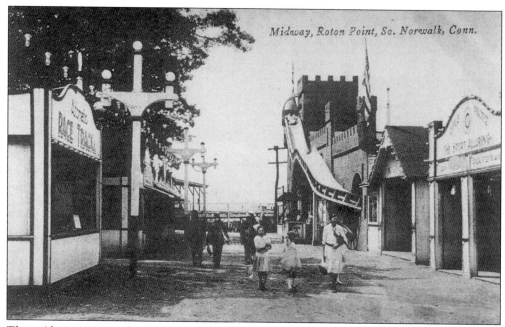

The midway contained many exciting attractions: a bowling ball game, Chinese games, a shooting gallery, a mechanical fortune teller, a fishpond game, and more. Above on the right is the fun house, which featured a slide that ran along the front of the building and deposited riders back inside. Of course, there were souvenirs as well, including postcards to send to friends and family. (Courtesy of the Robinson family.)

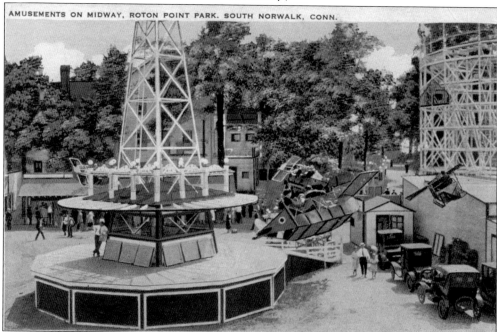

The excitement surrounding Charles Lindbergh's 1927 nonstop transatlantic flight from New York to Paris in a single-seat, single-engine aircraft inspired airplane swing rides such as this, with each plane bearing a name such as *Spirit of St. Louis*. (Courtesy of the Robinson family.)

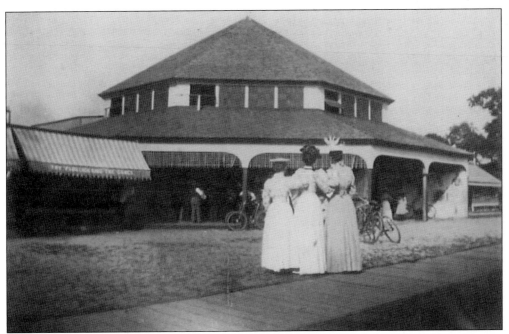

This 1897 photograph features the original carousel building, which was transformed into a vaudeville theater when the carousel was relocated to the other side of the park. In addition to vaudeville acts, there were also dog shows and juggling acts. There was an open-air photography gallery to the right of this building where people could obtain tintype photographs of their group. (Courtesy of the Robinson family.)

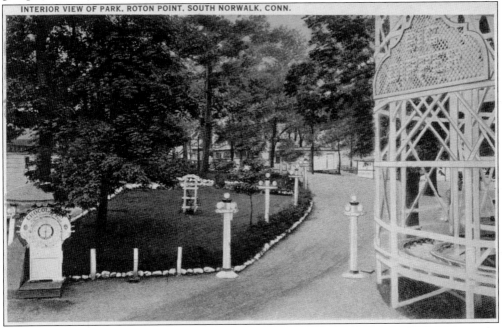

INTERIOR VIEW OF PARK. ROTON POINT. SOUTH NORWALK. CONN.

There was a weight guesser's scale near the eastern end of the Big Dipper roller coaster. In the grove, there was a gentleman known as Mr. Tiffany who would create jewelry with the buyer's name in gold wire. (Courtesy of Lisa Wilson Grant.)

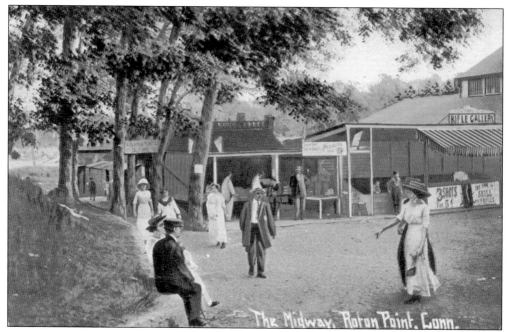

The midway had a rifle gallery where, for three shots for a nickel, one could "try your skill with rifles." People would compete to win prizes such as a basket of groceries, including "California Fruit" and other goodies. (Courtesy of Lisa Wilson Grant.)

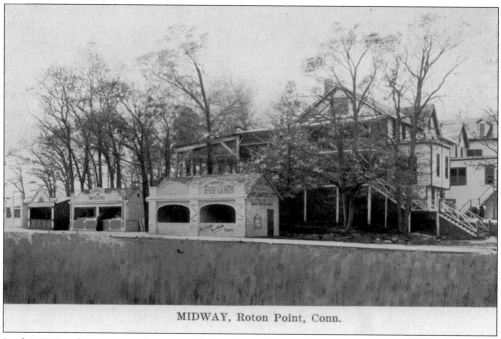

MIDWAY, Roton Point, Conn.

In the 1930s, there was a saltwater taffy booth run by Frank Pfahl and his helper Lulu Patrino. The saltwater taffy was made in a factory in Norwalk. There was fresh popcorn made every day, cotton candy, and a roasting machine for peanuts. (Courtesy of Lisa Wilson Grant.)

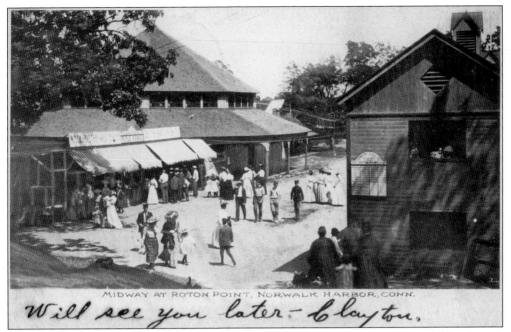

MIDWAY AT ROTON POINT, NORWALK HARBOR, CONN.

Will see you later - Clayton.

The bathhouse at the right, originally parallel to the beach, was later divided in half with each end moved 90 degrees to flank the octagonal building, opening up the view to the beach. The midway was then relocated by the amusements. The trolley schedule is posted on the building with points west on the left and points east on the right. (Courtesy of Lisa Wilson Grant.)

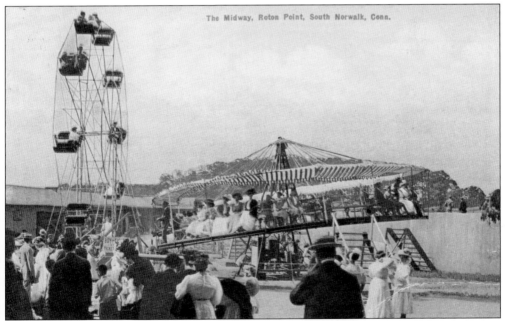

The Midway, Roton Point, South Norwalk, Conn.

Roton Point's Ocean Wave Ferris wheel is on the left side in this view of the midway. A fire consumed the west end of the carriage sheds (in the background) along with the Ocean Wave in 1913. (Courtesy of the Robinson family.)

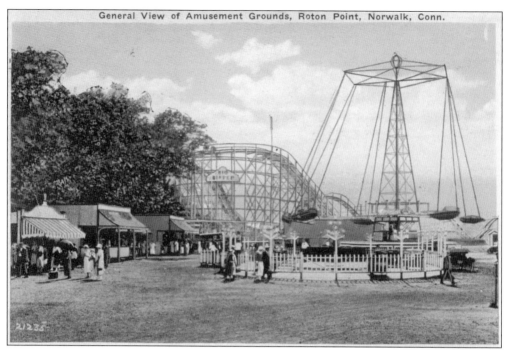

General View of Amusement Grounds, Roton Point, Norwalk, Conn.

Here is a view of the rides, games, and the Big Dipper roller coaster, which would greet parkgoers as they came from the parking lot or from the trolley station. By the time this image was taken, many concessions had been moved to this area. (Courtesy of the Robinson family.)

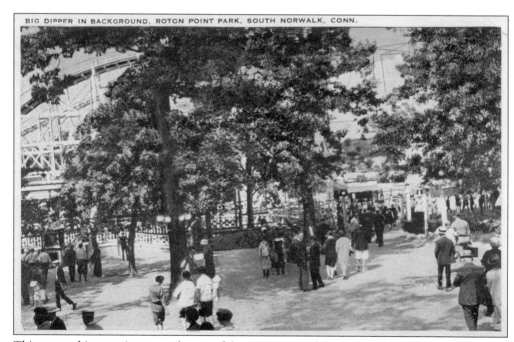

BIG DIPPER IN BACKGROUND, ROTON POINT PARK, SOUTH NORWALK, CONN.

This postcard image gives a good sense of the excitement of the Roton Point Park rides. Pictured here is the leafy approach to the Big Dipper from the grove. (Courtesy of Lisa Wilson Grant.)

92

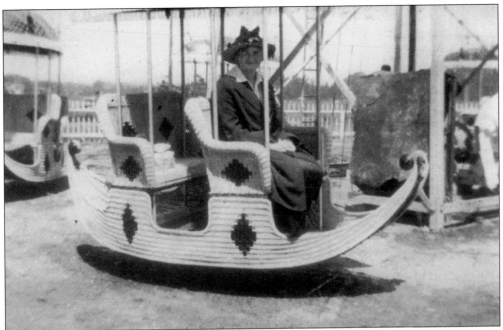

Modern amusement parks of today offer a much different experience than was offered back in the days of Roton Point Park, as evidenced by this unusually quaint wicker ride from around 1900 and the way the rider is attired. (Courtesy of the Robinson family.)

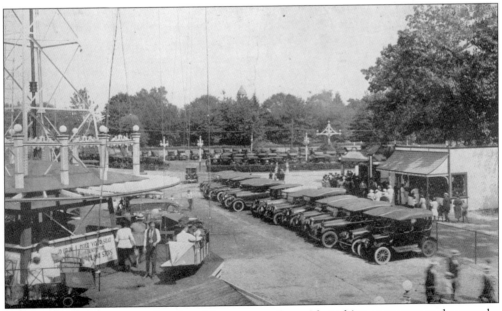

Apparently, there was a need to be a bit more creative with parking as more people came by automobile, as shown in this 1915 photograph. (Courtesy of the Robinson family.)

THE PARKING SPAC
From all parts of Ne
necticut the automob
level area, where com
the left may be seen
outing parties; in the
two of Roton's safe a
the background, anotl

HOLD TIGHT!—Noted as one
of the safest roller-coasters in
the country, Roton's Big Dipper
is as much a ride for the children
as it is for adults.

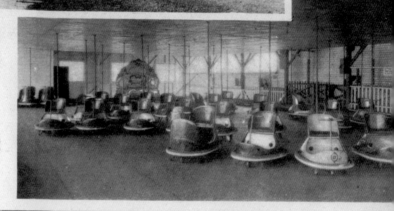

DRIVE YOUR OWN—The cars
of the Skooter are waiting to be
turned this way and that; fun
for all, from six to sixty.

Pictured here is the inside of a Roton Point Park brochure from around 1930 that illustrates

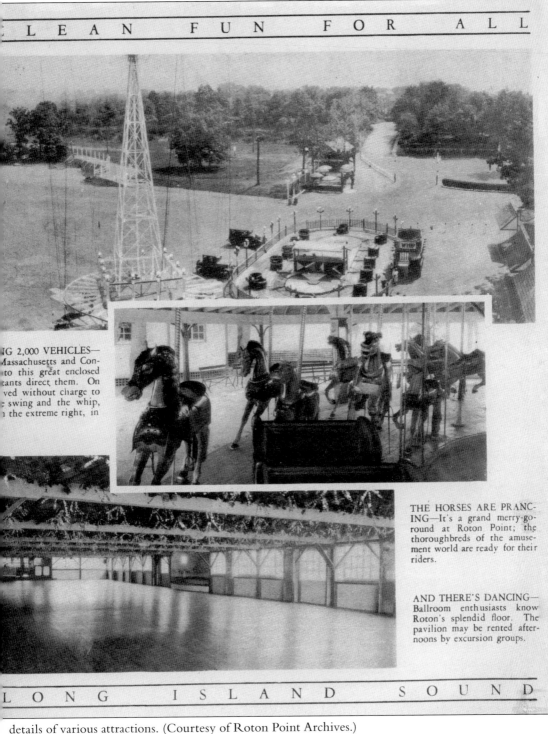

NG 2,000 VEHICLES—
Massachusetts and Con-
to this great enclosed
tants direct them. On
ved without charge to
swing and the whip,
the extreme right, in

THE HORSES ARE PRANC-
ING—It's a grand merry-go-
round at Roton Point; the
thoroughbreds of the amuse-
ment world are ready for their
riders.

AND THERE'S DANCING—
Ballroom enthusiasts know
Roton's splendid floor. The
pavilion may be rented after-
noons by excursion groups.

details of various attractions. (Courtesy of Roton Point Archives.)

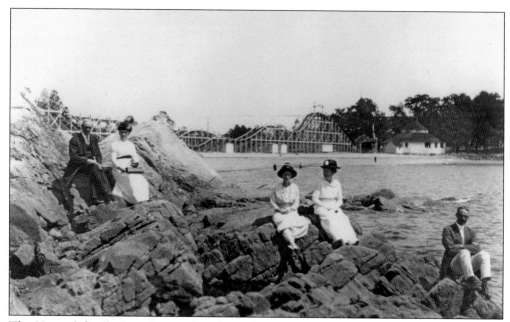

The Howard family is posing on Price's Rocks with West Beach and the Tango Dip roller coaster in the background of this 1914 photograph. (Courtesy of Roton Point Archives.)

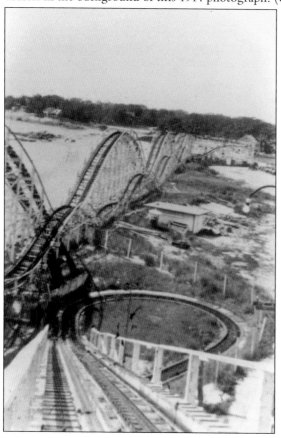

One can sense the thrill about to be had from atop the high point of the roller coaster. Ingersoll Engineering and Constructing built this first version of the roller coaster, and it extended the full length of the beach in an out-and-back style. (Courtesy of Roton Point Archives.)

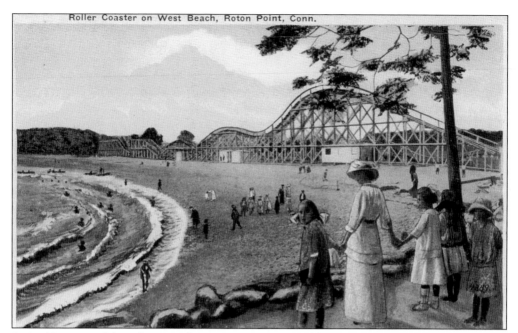

Attired in some of their finest outfits, a woman and several young girls view West Beach and the expansive view of the roller coaster from the edge of the grove. One of the most amazing events reserved for the Fourth of July was held here on the beach: the balloon ascension complete with acrobatics in midair. At a certain elevation, the acrobat, colorfully dressed, would climb onto the edge of the basket, perform a few stunts, and descend slowly by parachute, landing sometimes in the sound and sometimes in the tidal mud. (Courtesy of Lisa Wilson Grant.)

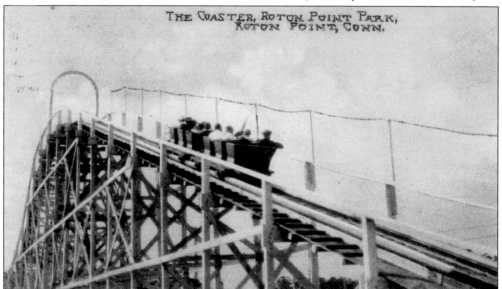

THE COASTER, ROTON POINT PARK, ROTON POINT, CONN.

Heading up the tallest peak of the Tango Dip, there is a mixed feeling of nervousness and excitement. In 1924, enhancements were made by Miller & Baker of New York City. The roller coaster was lengthened 1,000 feet and renamed the Big Dipper, as its highest peak was then 50 feet instead of 30 feet. It still extended the entire length of the beach at that time. (Courtesy of the Robinson family.)

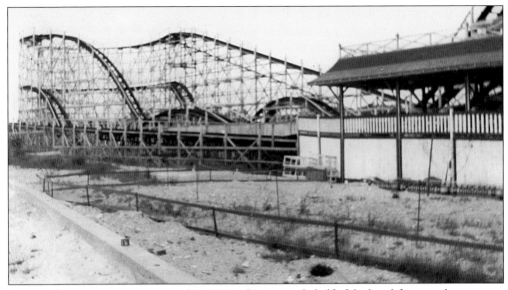

A new roller coaster was constructed in 1934, taking up only half of the beachfront, as the property to the west was sold to Ralph Case. The roller coaster planner was Harry C. Baker of New York City, and the builder was Edward Lundberg of Malden, New York. This version had the first peak at 63 feet and went up to 60 miles per hour. There was a contest to name the new roller coaster, and a man named Jack T. Francis of Norwalk won the contest, naming it Skylark. The loading and unloading platform of this roller coaster exists today as Bayley Beach's picnic pavilion. (Courtesy of Roton Point Archives.)

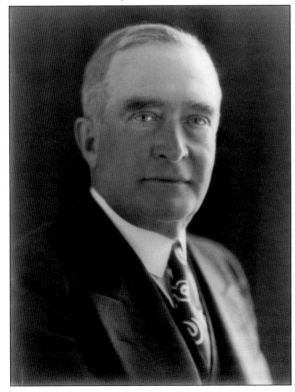

Neville Bayley was born in 1863 in England and immigrated to the United States in 1879. He was a sales clerk in Chicago before moving to Pittsburgh, Pennsylvania, where he went into the hotel business. He worked for New York Central Railroad, traveling the country in search of factory sites. By 1909, Bayley decided there was an assuring future in the outdoor amusement field, so he turned to the construction and operation of riding devices, particularly roller coasters. Also, during that year, he married Elizabeth Alter. In 1914, he leased Roton Point Park, eventually purchasing the property from Connecticut Railway and Lighting Company in 1928. He died in 1948. Today, Rowayton's public beach, once part of Roton Point Park, is named in his honor. (Courtesy of the Robinson family.)

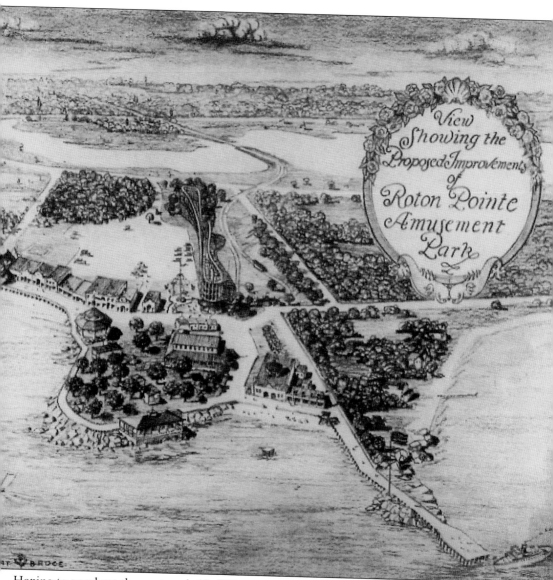

Hoping to purchase the western half of West Beach, Ralph Case wrote Neville Bayley a New Year's card in 1928 that included this illustration of what could be. His idea was to rotate the roller coaster 90 degrees (from its beachfront position) and add a boardwalk with a tea room. Although this plan never materialized, Case did eventually purchase the western end of the property, which he developed into Ballast Reef Club (now Wee Burn Beach Club) and residential lots. (Courtesy of Roton Point Archives.)

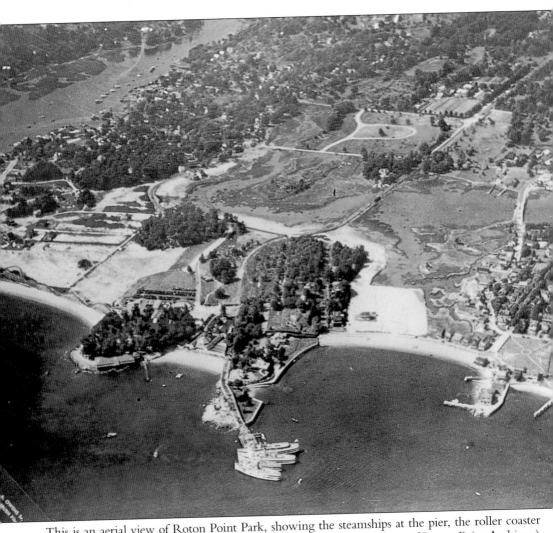

This is an aerial view of Roton Point Park, showing the steamships at the pier, the roller coaster across the beach, and the Five Mile River in the background. (Courtesy of Roton Point Archives.)

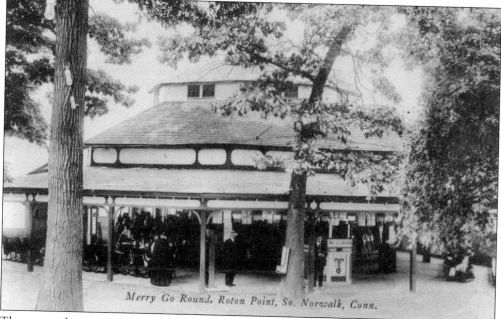

Merry Go Round, Roton Point, So. Norwalk, Conn.

The carousel was one of Roton Point's main attractions. If the brass ring was caught while riding the carousel, the rider won a free ride. (Courtesy of the Simmons family.)

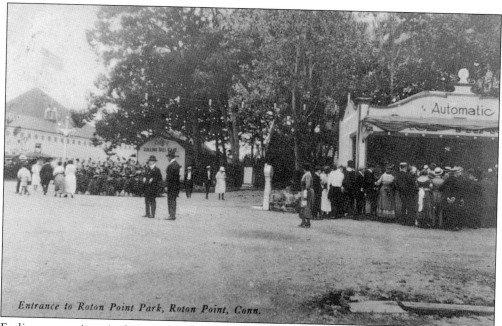

Entrance to Roton Point Park, Roton Point, Conn.

Earlier concessions included the automatic racetrack and a rolling ball game. The games often changed to reflect current events, such as the Kill the Kaiser game during World War I. Park visitors could try a palmistry, shooting gallery, skee ball, fishpond, a penny arcade, bowling, a balloon game, and a glass blower's booth. Nearby, the Skooter, added in 1926, was an electrical bumper car ride that had 10 cars, each with a steering wheel and foot pedals. (Courtesy of the Robinson family.)

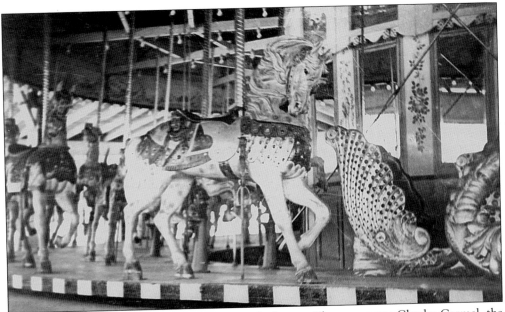

The carousel included both horses and menagerie figures. The carver was Charles Carmel, the artist with the most realistic style of the Coney Island–style carvers. As seen on these figures, particularly on the seashell-shaped chariot, glass jewels were added throughout by carousel manufacturer Michael D. Borelli. (Courtesy of the Robinson family.)

The central pillar of the carousel had a humorous black cat theme that was hand painted by Carl Heinrich Quenzel of New York in 1932. Many people remember the sparkling mirrors that reflected the riders' images as they rode around and that there was a choice of riding stationary horses or ones that went up and down. (Courtesy of the Robinson family.)

This young toddler is riding atop a goat carousel figure. One can tell it is a goat by the hair on its legs and beard. (Courtesy of the Robinson family.)

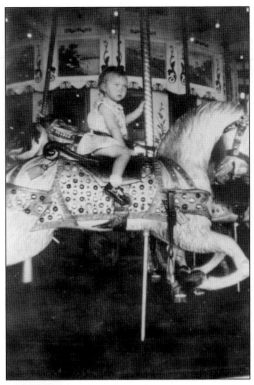

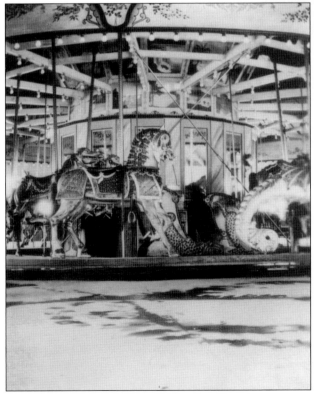

The figure in the center is a magnificent warhorse, and the one at the right is a hippocampus, which is usually depicted as half horse, half serpent. (Courtesy of the Robinson family.)

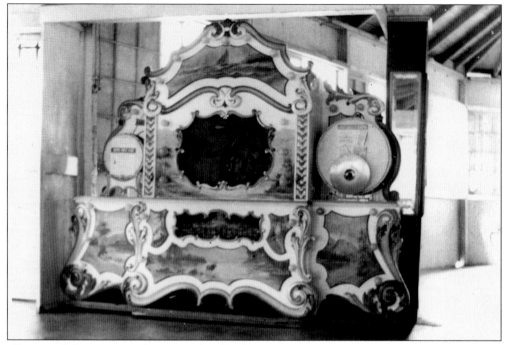

The Roton Point carousel contained a Wurlitzer 153 Duplex Orchestral Organ; the duplex roll frame allowed one roll to play while the other one rewound so the organ was never silent. (Courtesy of the Robinson family.)

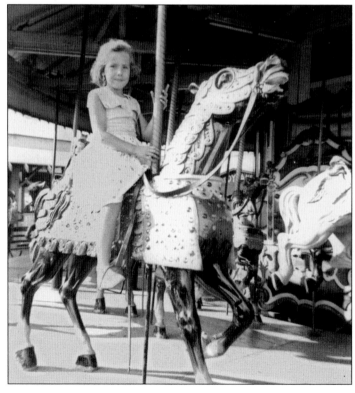

After the close of the park in 1942, the Roton Point carousel was relocated to Wildwood, New Jersey. This photograph was taken there in 1957. (Courtesy of the Robinson family.)

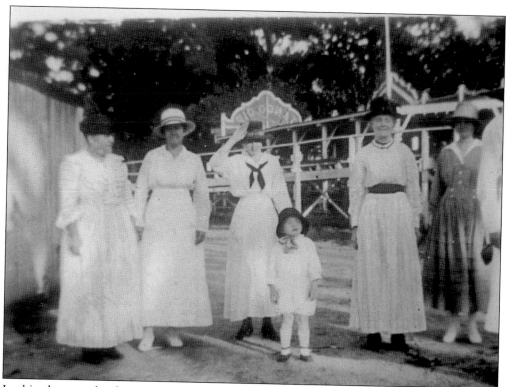

In this photograph of a group of women with a child at Roton Point Park, the roller coaster sign behind them reads "Tango Dip" backwards, which dates this image to sometime before 1924 when the roller coaster was expanded and became the Big Dipper. (Courtesy of the Robinson family.)

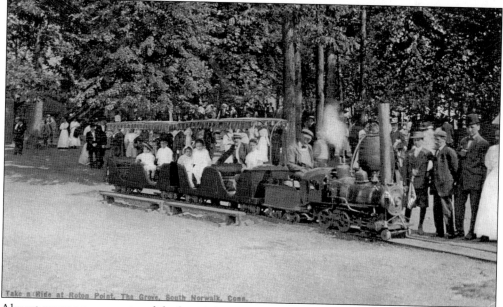

Almost every amusement park had a miniature train ride, and Roton Point was no exception—this one began its excursions in the grove. (Courtesy of Lisa Wilson Grant.)

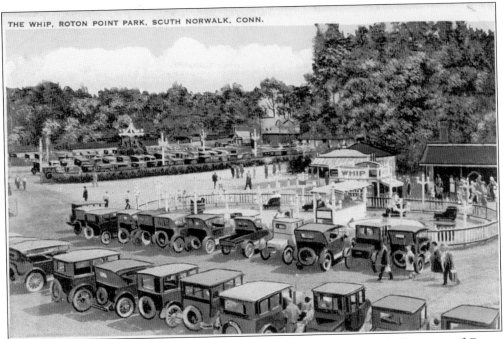

The Whip, added in 1924, was a ride designed and built by W.F. Mangels Company of Coney Island, New York; it was patented in 1914 and became an extremely popular ride. (Courtesy of Lisa Wilson Grant.)

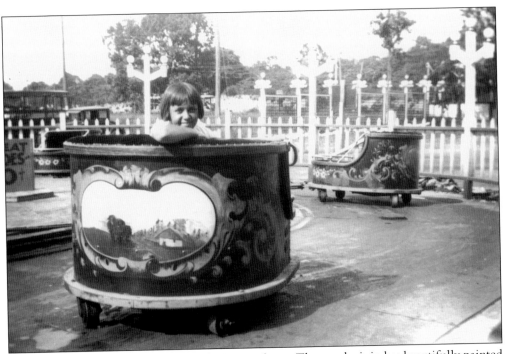

A young girl is enjoying the Whip in the image above. The car she is in has beautifully painted details. (Courtesy of the Robinson family.)

Seven

GREETINGS FROM THE PARK

Some of the most endearing, memorable, amusing, and downright strange ephemera is found in the various advertising cards that were distributed to promote places like Roton Point Park. Often, these cards were distributed in New York City with the intent of making Roton Point a city resident's next destination; one can only hope that the enticed visitors were not let down.

Many of the cards in this category are clearly generic in nature; while they may be labeled "Roton Point," the beach scenes depicted are most likely big ocean beaches instead. The fact that so many of these fleeting cards still exist, though, suggests that visitors to Roton Point Park were enchanted enough to hold on to any souvenir they could to recall their trip.

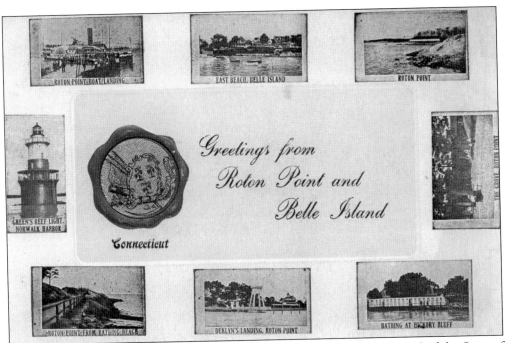

This postcard depicts all of the sights around Roton Point, including the seal of the State of Connecticut. (Courtesy of Lisa Wilson Grant.)

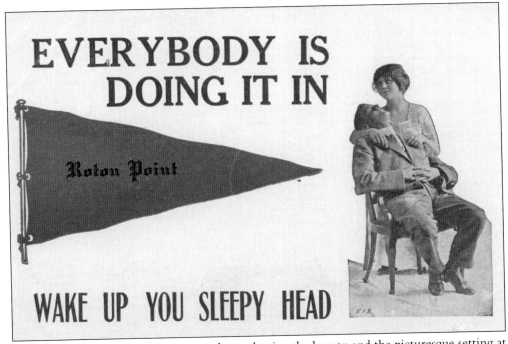

"Wake up you sleepy head," one can relax and enjoy the beauty and the picturesque setting at Roton Point. (Courtesy of the Robinson family.)

The prettiest park on Long Island Sound was a place where one could find people from all religious denominations having a fun day with family and friends. There was much to do and to see, including the beach, picnic areas, dining, and boating for all to enjoy. (Courtesy of Roton Point Archives.)

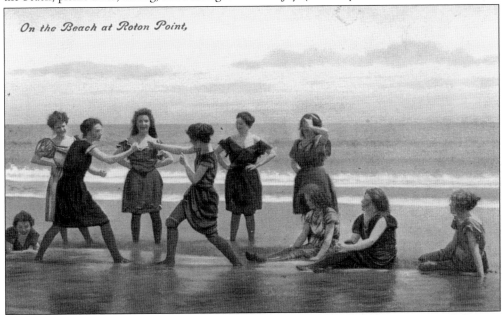

On the Beach at Roton Point,

Bathing beauties are frolicking at the edge of the surf at Roton Point. Notice how much clothing they actually are wearing as their swimming attire, including long dresses and hose— all on a hot summer's day. (Courtesy of the Robinson family.)

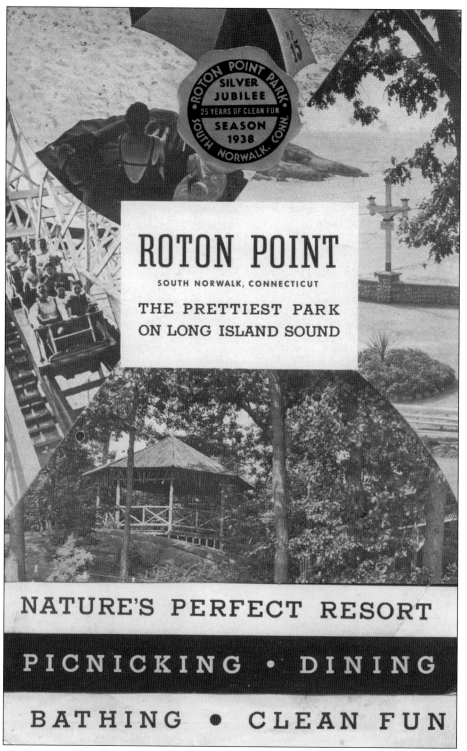

ROTON POINT

SOUTH NORWALK, CONNECTICUT

THE PRETTIEST PARK
ON LONG ISLAND SOUND

NATURE'S PERFECT RESORT

PICNICKING • DINING

BATHING • CLEAN FUN

The front cover of this Roton Point Park brochure for Silver Jubilee Season 1938 touts 25 years of clean fun. (Courtesy of Roton Point Archives.)

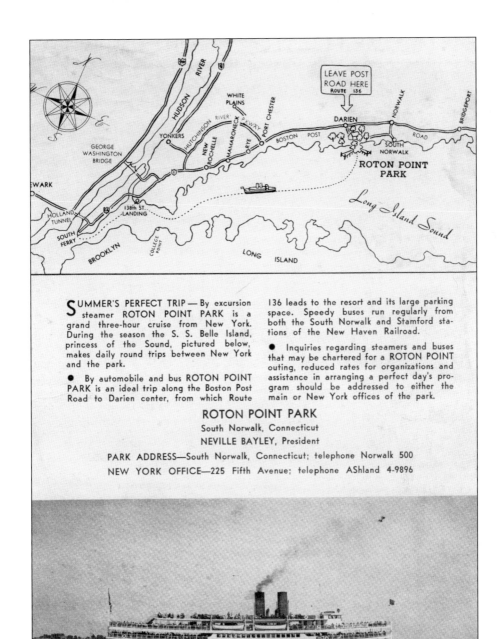

SUMMER'S PERFECT TRIP — By excursion steamer ROTON POINT PARK is a grand three-hour cruise from New York. During the season the S. S. Belle Island, princess of the Sound, pictured below, makes daily round trips between New York and the park.

● By automobile and bus ROTON POINT PARK is an ideal trip along the Boston Post Road to Darien center, from which Route 136 leads to the resort and its large parking space. Speedy buses run regularly from both the South Norwalk and Stamford stations of the New Haven Railroad.

● Inquiries regarding steamers and buses that may be chartered for a ROTON POINT outing, reduced rates for organizations and assistance in arranging a perfect day's program should be addressed to either the main or New York offices of the park.

ROTON POINT PARK

South Norwalk, Connecticut

NEVILLE BAYLEY, President

PARK ADDRESS—South Norwalk, Connecticut; telephone Norwalk 500

NEW YORK OFFICE—225 Fifth Avenue; telephone AShland 4-9896

S. S. BELLE ISLAND

Shown here, the back cover of the 1938 brochure provides directions to Roton Point by boat, train, bus, and automobile. Apparently, Roton Point maintained an office in South Norwalk and on Fifth Avenue in New York City. This would be the last summer season before the September 1938 hurricane. (Courtesy of Roton Point Archives.)

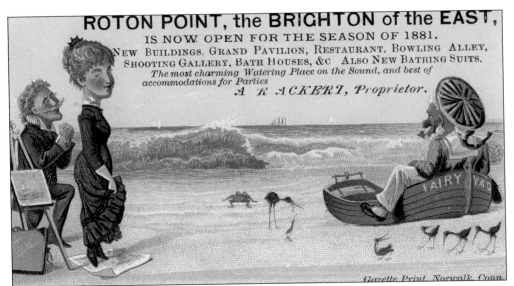

Sometimes called "The Brighton of the East," this humorous card from 1881 announces the opening of the point for the summer. A salty old sailor seems to be intruding on a romantic moment. (Courtesy of the Simmons family.)

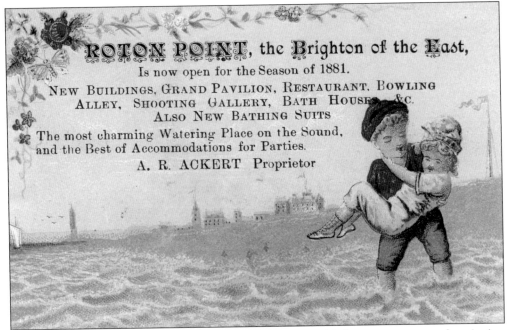

Romance blooms at Roton Point. This lovely card from 1881 shows a young couple enjoying the cool saltwater of the sound, "the most charming Watering Place" around. Note that they are also announcing the year's newest bathing suits. (Courtesy of the Robinson family.)

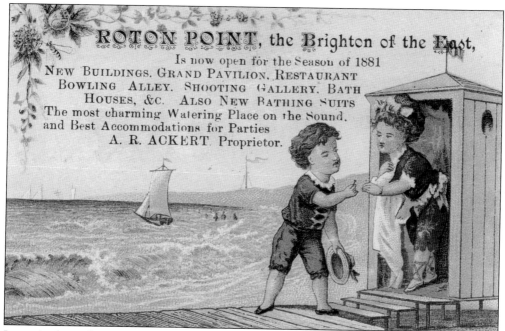

It was in the early 1800s that people began to flock to the beaches for seaside amusement, and there was none better than the gorgeous Roton Point. The young man pictured on this card from 1881 is trying to entice his lady love to come out of the changing room and show him her new stylish bathing attire. (Courtesy of the Robinson family.)

Published in 1881, this charming series of advertisement cards, depicting adorable cherub figures, seemed to be a favorite of A.R. Ackert, proprietor of Roton Point at the time. (Courtesy of the Robinson family.)

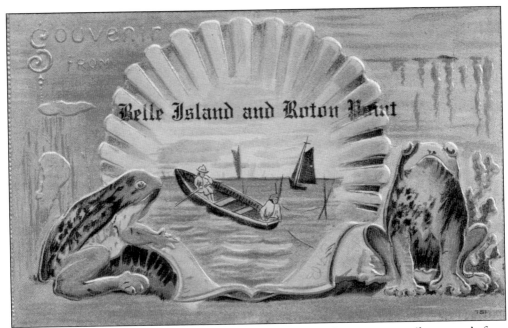

Whether or not one likes frogs, this early souvenir postcard may put a smile on one's face, especially since it is advertising the beauty of Bell Island and Roton Point. (Courtesy of the Robinson family.)

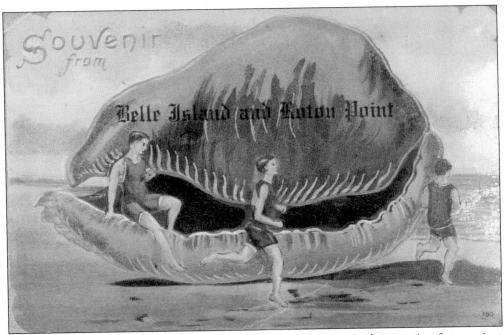

This souvenir card shows three young boys in search of fun seemingly emerging from a giant clamshell. (Courtesy of the Robinson family.)

ROTON POINT BATHS

Patrons Will Please Observe The Following Rules

1. Remember your room or locker number.
2. Check your valuables.
3. The proprietor is not responsible for property left in the bath rooms.
4. Smoking, loud talking, vulgar or profane language is prohibited.
5. Please report discourtesy or lack of attention on the part of our employees.
6. Patrons will be held responsible for damage to suits or other property.
7. Tickets with suit and towel must be returned to doorman.
8. Our limit of liability on valuables checked is Twenty-five ($25.00) Dollars.

FOR
SUNBURN

(A HEALING CREAM)

Mentholatum

ALL DRUGGISTS GUARANTEED

Judging from Roton Point Park's popularity with young families, the rules spelled out on this advertiser-sponsored bathhouse sign were either well-enforced or not necessary at all. (Courtesy of the Robinson family.)

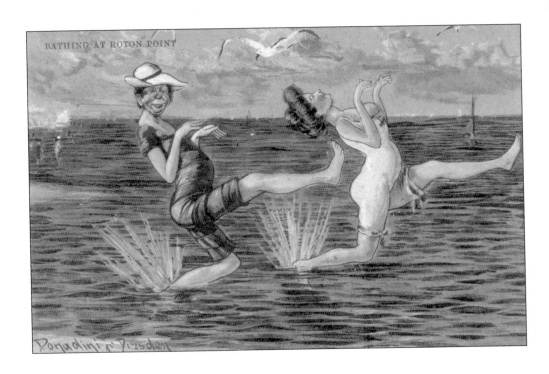

Saucy postcards of this era were a breath of fresh air. They were considered a bit risqué for some, yet others found them to be fun. It is amusing to look at the cards in detail, especially the artists' interpretation of a day at the beach. (Courtesy of the Robinson family.)

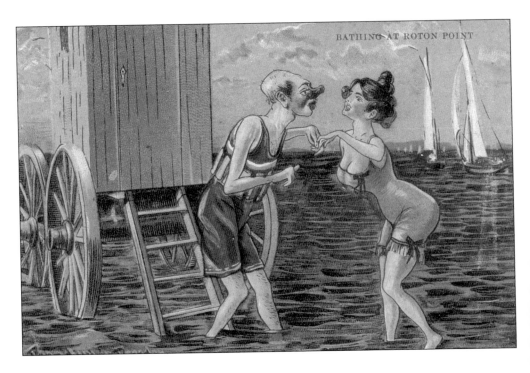

Sweet and sassy continues to be the theme in these renderings depicting comical figures at the beach. Though these drawing may have lifted some eyebrows at that time, they most certainly brought attention to Roton Point and the fun that can be had in the water. (Courtesy of the Robinson family.)

BATHING AT BELLE ISLAND

These Ziegfield-esque beauties seem to be sharing a bit of gossip while wading in the water at the edge of the beach, hoping to attract the attention of an admirer. (Courtesy of the Robinson family.)

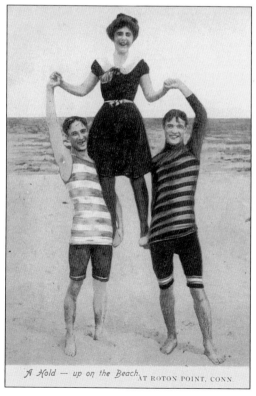

A Hold — up on the Beach. AT ROTON POINT, CONN.

This image shows a "hold-up on the beach" at Roton Point. It did not really take two strong men to hold up such a dainty young lady. By the look on their faces, it appears that everyone was having a grand old time. (Courtesy of the Robinson family.)

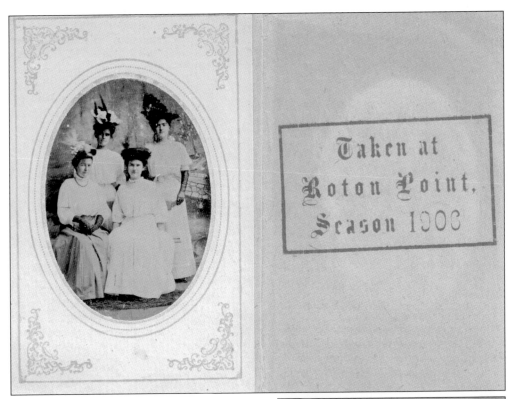

This tintype photograph of four women was taken in 1906. Each tintype had a paper souvenir sleeve to frame the photograph. (Courtesy of Lisa Wilson Grant.)

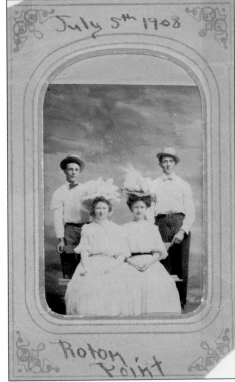

Two couples pose for a souvenir tintype photograph on Sunday, July 5, 1908. Judging from the women's elaborate hats and the men's straw boaters, this fetching foursome most likely did not come to Roton Point for the rides. (Courtesy of Lisa Wilson Grant.)

This lovely real-photo postcard depicts two very well-dressed women enjoying an afternoon before a painted backdrop of beach and rocky outcroppings. (Courtesy of Lisa Wilson Grant.)

This image from around 1900, a tintype of Abigail Huson and her daughters Gladys Louise and Ruth, was mounted in a case with an ornate golden frame. (Courtesy of Lisa Wilson Grant.)

Eight

THE FINAL YEARS

On Wednesday, September 21, 1938, New England was pummeled square on by a powerful, deadly storm known today as the Great Hurricane of 1938. Hitting the Connecticut shoreline in the afternoon, the storm did not bypass Roton Point. On top of already high tides due to the combination of autumnal equinox and full moon, the hurricane produced a storm surge of 14 to 18 feet. While damage was extensive, the park's midway and rides were particularly hard hit, perhaps due in part to their barely-above-sea-level location. The pier was in shambles, yet somehow the hotel, atop its hill, survived intact.

The park managed to patch itself up and reopen the following season on May 30, 1939. But the first blow had been struck, and other events now conspired to bring the golden age of Roton Point Park to a close. It became harder to find workers as the nation headed toward war, and in 1941, the trolley company released its rights to Roton Point, as it was no longer using the premises. Fuel rationing severely limited the car and bus traffic that had become the predominant way of getting to Roton Point, and the big excursion boats that had been the lifeblood of the park for so long ceased as well, the boats now being conscripted to military use.

Within this context, owner Neville Bayley decided to sell and two distinct groups expressed interest. A group from Rowayton would buy West Beach (formerly the site of the roller coaster) and the land immediately behind it. The beach was named Bayley Beach and is still in existence today serving the Sixth Taxing District of Norwalk, better known as Rowayton.

Noting the long history of Roton Point usage by its town's residents, a group from nearby New Canaan, led by George McKendry (who had a home on neighboring Bell Island), wanted landlocked New Canaan to purchase the remaining 13 acres of Roton Point, including East Beach, the pier, the grove, and most of the buildings. New Canaan residents voted to approve the purchase, but special state legislation had to be passed allowing a town to buy land in another jurisdiction. Once that was done, the town voted again, but with a different result. Staring at a world war, the voters turned down the purchase with a final vote of 103 in favor and 356 against. As Bayley could not wait, McKendry, along with several partners, took up the option and had purchased the property several months before the actual vote. After the defeat, the partners decided to develop the property as the Roton Point Beach Club, a family club that was a precursor to today's Roton Point Association.

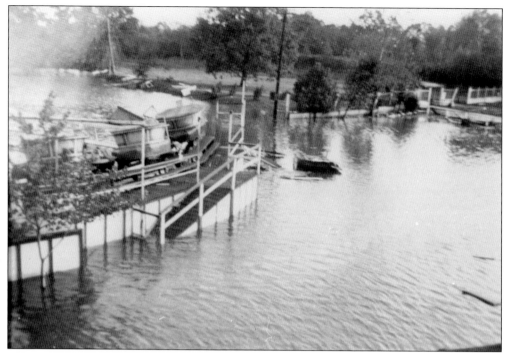

Devastating the New England shoreline, the Great Hurricane of 1938 wreaked havoc on the beloved Tumble Bug ride. (Courtesy of the Robinson family.)

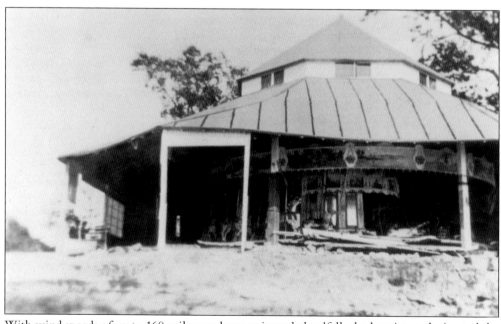

With wind speeds of up to 160 miles per hour as it made landfall, the hurricane decimated the carousel, leaving behind a few lonely horses while carrying the organ out to sea. (Courtesy of the Robinson family.)

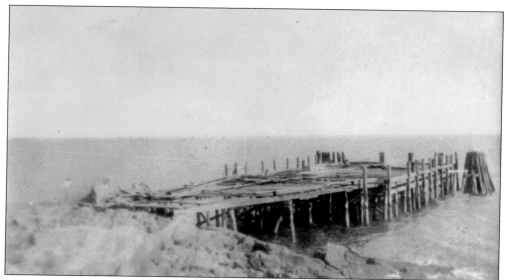

The great pier that had welcomed the steamships from New York for so many years was severely damaged by the record tidal waves estimated at 15 to 30 feet high. (Courtesy of the Robinson family.)

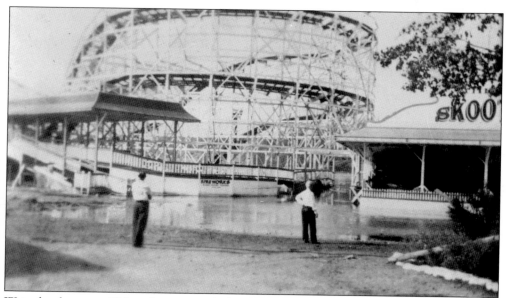

Water levels rose to 17 feet above normal, destroying the Skooter building and part of the roller coaster. (Courtesy of the Robinson family.)

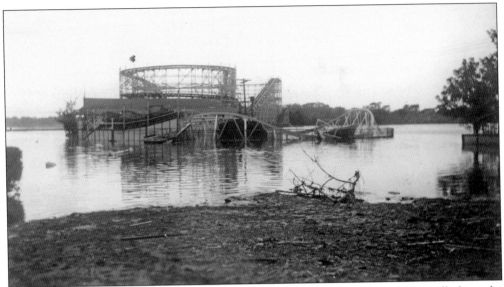

Nicknamed the "Long Island Express," the storm ripped through communities all along the Connecticut coastline. Roton Point's roller coaster was in shambles, along with almost all of its other rides. (Courtesy of the Robinson family.)

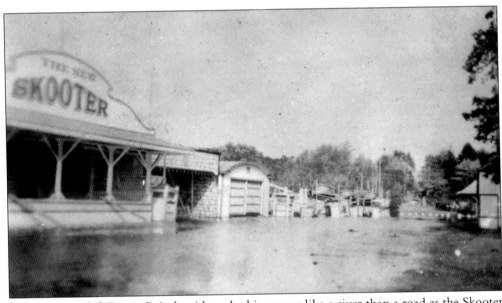

The hurricane left Roton Point's midway looking more like a river than a road as the Skooter and other concessions were flooded out. The penny arcade building, the curved-roof structure seen in the middle of this image, was later salvaged, placed on a barge, and transported to a waterfront site in East Norwalk, the move occurring after midnight to take advantage of high tide. Resurrected as a waterfront restaurant, it was known at various times as the Seaview, Sandpiper, Hurricane's, and Bosun Pipe. Today, completely rebuilt, it is called Harbor Lights. (Courtesy of the Robinson family.)

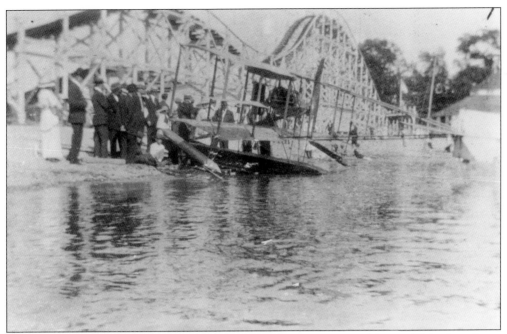

The 1938 hurricane was the worst natural disaster in Connecticut history. This view shows the devastation the storm wrought on the Roton Point roller coaster. (Courtesy of Roton Point Archives.)

Looking from West Beach towards the grove, one can clearly see the foundation of the carousel. As indicated by the fence, this spot straddles the current-day demarcation line of the Roton Point Association and Bayley Beach. (Courtesy of the Robinson family.)

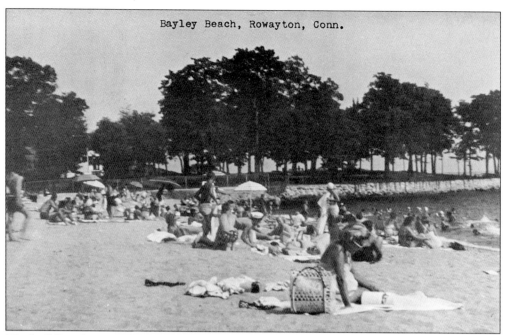

Bayley Beach, Rowayton, Conn.

The building that once housed the ramp and entrance to the great roller coaster remains today as the pavilion at Bayley Beach. This view is from Bayley Beach, formerly West Beach, looking back towards the Roton Point picnic grove. (Courtesy of the Robinson family.)

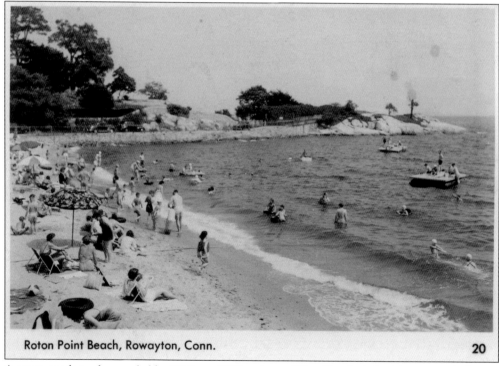

Roton Point Beach, Rowayton, Conn. 20

A more modern-day, probably 1940s or 1950s, view of East Beach, is looking towards Sunset Rock, the pier and great steamships long gone. (Courtesy of the Robinson family.)

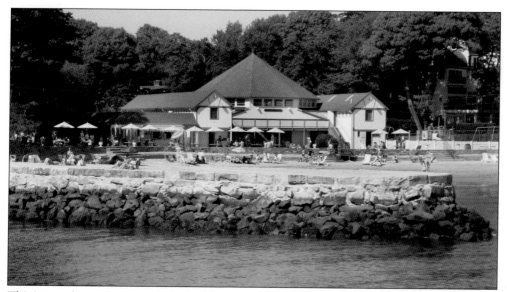

This image shows the Roton Point bathhouse in 2010; in the late 1980s, the entire building was completely rebuilt, and the original octagonal roof was lowered back into place from a crane. Today, the building includes 400 individual lockers (each four feet by four feet with a bench), a snack bar facility, and modern bathrooms with hot water showers. It now serves swimmers from both the beach and a 25-meter swimming pool. (Courtesy of Cam Hutchins.)

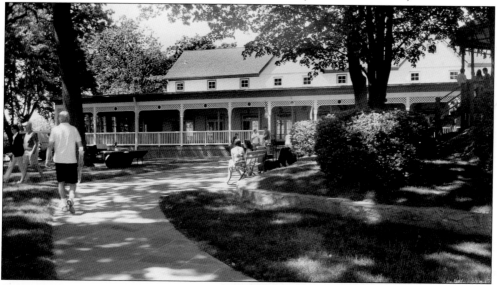

Shown here, the Roton Point Hotel has moved into the 21st century as well. No longer an actual hotel (though still called that), it was rebuilt in 2001 with careful attention to keeping its original details intact. Today, it houses the manager's office, a club meeting room, a caterer's kitchen, modern bathrooms, a large room used for parties and all-club meetings, a sailing school room and locker, and a small apartment and maintenance workshop below. In the former hotel lobby, the original check-in desk area now acts as a serving bar during club events, and on certain summer nights, with the breezes blowing in off the moonlit sound and the waves lapping the beach below, the large open porch still resounds with live music, dancing, and good times. (Courtesy of Cam Hutchins.)

www.arcadiapublishing.com

Discover books about the town where you grew up, the cities where your friends and families live, the town where your parents met, or even that retirement spot you've been dreaming about. Our Web site provides history lovers with exclusive deals, advanced notification about new titles, e-mail alerts of author events, and much more.

Find Your Place in History.